# FACES OF BOLTON

## RAY JEFFERSON & JEFF LAYER

First published 2017

Amberley Publishing
The Hill, Stroud
Gloucestershire, GL5 4EP

www.amberley-books.com

British Library Cataloguing in Publication Data.
A catalogue record for this book is available from the British Library.

ISBN 978 1 4456 5597 0 (print)
ISBN 978 1 4456 5598 7 (ebook)

Origination by Amberley Publishing.
Printed in Great Britain.

# FOREWORD

*If asked, Bolton people are very clear that their town lies in Lancashire rather than Greater Manchester, and what's more, the Post Office agrees with them, having kept the Lancashire address until this day. This is evidence, if it were ever needed, of the fierce loyalty to the town and its history felt by local people, and which has been strongly expressed by those we have met while making this book.*

*Bolton grew after its market charter was granted in the thirteenth century and soon became known for its woollen goods. Later on, fustian and then cotton products were the foundation for its significant role in the Industrial Revolution, as 'king cotton' underpinned the growth and prosperity of the nation. In subsequent years other industries have come and gone and, today, like many other towns, Bolton's economic activity is very diverse. The strength of feeling for the town is one thing that hasn't changed however. Whether you meet recent arrivals or people whose families stretch back through the years, the sentiment for Bolton is much the same – it's a town that gives a friendly welcome, is built on the ingenuity and hard work of many generations, has some handsome architecture, and is well positioned in relation to the 'northern powerhouse' as well as the countryside and coasts of North West England.*

*The authors are most grateful to the people included in this book for their warm welcome and the generous gift of their time. If there are any errors in the stories told here, then please blame the authors. We have been delighted to spend time with so many remarkable people and hope we have captured a little of what makes them so special.*

# FACES OF BOLTON

## AGNES JUSTIN
### SUDANESE REFUGEE

Agnes was born in Sudan. Along with her mother, Agnes helped raise a family of two brothers and seven sisters. Unfortunately Agnes and her family were caught up in the civil war that affected Sudan and one night rebels came to her home and took her husband, whom she never saw again.

Agnes decided that for the safety of her two children she should flee Sudan. Along with other members of her family, she travelled to neighbouring Uganda where she was placed in a United Nations refugee camp, where she lived for several months until her application for refugee status was approved. She and her children were then allowed to travel to Britain where she was provided with accommodation in Great Lever and then in north Bolton where she presently lives.

Agnes explains that when she came to Britain she could speak no English and found British currency difficult to understand. But with great perseverance, attending college and with a lot of help from friends at her local church, she soon came to grips with the language and the money – but she admits she still finds reading English difficult.

Agnes is very complimentary towards the people of Bolton who, she says, are friendly and welcoming wherever she goes.

## ALAN PRINCE
### TENNIS ENTHUSIAST

An early ambition to become a chemistry teacher was fulfilled when Alan secured a post with Bolton School. However Alan had also been enthusiastic about tennis, taking up the game at the age of ten. This led to a long association with the Longsight tennis club, where Alan is still the secretary. He serves on the Bolton Sports Federation Tennis Administrative Committee, one of the responsibilities being to adjudicate on disputes. Bolton's tennis league is significant in that it draws from a wide catchment and has players of county standard. Alongside his tennis activities with Longsight, Alan has also been a prime mover with tennis at Bolton School. Soon after joining, Alan was organising the senior school tennis arrangements. Saturdays were taken up with team matches across the north of England, where Bolton School teams competed successfully. During the 1980s the under 15s team won the Midland Bank Schools Tennis Team Competition in Telford.

Starting in the 1970s, Alan and a couple of colleagues agreed to take around thirty fifth and sixth formers from Bolton School to visit Europe each year. This continued until he retired, with destinations including Greece, Turkey, Spain, Portugal and Poland.

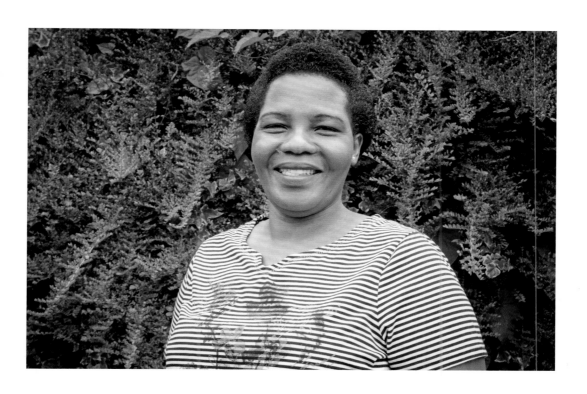
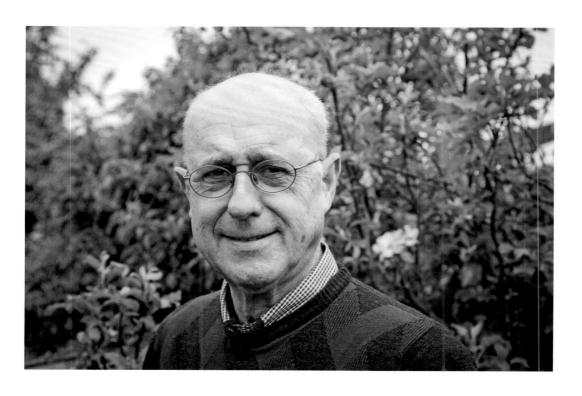

# FACES OF BOLTON

## ANDREW TAIT
### PRINTER

The family print business, Craftprint, has been active in Horwich, where Andrew was brought up, for more than thirty-five years. Back in 1980 the local printer was virtually the only way of obtaining leaflets, tickets, posters and booklets – a far cry from how things are today in the competitive digital age. Andrew and his brother took on the business when their father retired and have been careful to keep the firm up to date and successful in a changing and challenging climate for the industry as a whole. The traditional letterpress methods have given way to digital printing with its greater flexibility in terms of design and quantities. Andrew believes it is important for the business to support the local community and has been a patron for the Bolton Lads and Girls Club for many years as well as lending support to the Samaritans and Bolton Hospice. On a more personal front Andrew is the treasurer of the Astley Bridge Football Club, which currently fields six teams in the Bolton/Bury district junior football league, the largest in the country with around 650 teams.

## ANDY GRANT
### ENTHUSIASTIC SUPPORTER OF CHARITY

Andy has made his career with British Aerospace, and then with their successors MBDA. However he devotes much of his spare time to support the Lagan Foundation, which assists families facing the trauma of having a young child with a heart defect or complex feeding difficulties. Andy's involvement came about when his nephew's daughter, Lagan, was born with a heart defect. Although she was able to come home after treatment at Alder Hey Hospital, her condition was too complex and she unfortunately passed away in 2011. Her mother, Carren Bell, recognised the need for parents to be given support when facing those kinds of difficulties, and her charity was born.

Andy's involvement started when he helped organise a sponsored walk from Alder Hey to the then Reebok Stadium in Bolton. He took part in the walk dressed as a giraffe – of course. That event has prompted a lot of further fundraising activity and the charity has developed to the point where it now offers services and training across the country including not only Alder Hey but also Great Ormond Street children's hospital. Andy keeps up the fundraising efforts of course, and you may see him dressed as a giraffe sometime soon.

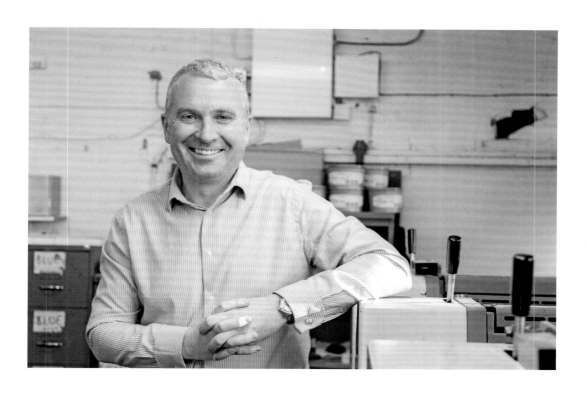

## ANGELA KELLY
### JOURNALIST

*Angela had always wanted to be a journalist since she was a teenager. Her career was launched when she was offered a job with the* Stretford and Urmston Journal *as a junior reporter. She remembers how journalists and certainly newspaper editors had a good position in the local community at that time – on a par with teachers. Angela honed her skills on public inquests, courtroom dramas and the odd murder. She particularly remembers the revered reporter Harry Green who had been reporting at the courts in Strangeways for more than thirty years and who was a great example and teacher. She also interviewed Jimmy Hendrix about six months before he died.*

*After winning an award in her final exams Angela eventually joined the* Bolton Evening News *as a general reporter. In those days deadline pressures were high, yet travelling around was by bus, and copy was submitted from public phone boxes – a very different world to today. After six years, Angela was persuaded to apply for the job of Women's Editor – a 'wonderful job' taking an interest in fashions, food, and families, and interviews with celebrities such as Max Bygraves and Jackie Collins.*

*Subsequently Angela became the Features Editor at the time when the newspaper world was being revolutionised by the introduction of computers. Twelve years on, Angela returned to writing, finding her own stories for the newspaper. Freelancing followed, including work for the* Manchester Metro News *and the* Lancashire Magazine. *Today, as an award-winning journalist, Angela helps businesses and charities to understand the world of journalism. Interestingly she also continues to write for the* Bolton News.

*As a Boltonian she believes there is something uniquely attractive about Bolton. A history of philanthropy and ambition has left a great legacy for the town. The university is building on this by bringing a lot of people and investment to the town. This is complemented by an outward-looking Octagon Theatre, a rich vein of voluntary groups and a diverse cultural tapestry.*

# FACES OF BOLTON

## ANNE HOWARTH
### BROWN OWL (RETIRED)

Anne has been involved in the Guide movement much of her life. She was a Brownie but then dropped out and was nineteen before she renewed her interest in Guiding. She was asked to help with the cubs at Longsight Methodist Church. Within a few weeks she was invited to become a Guide leader, which she accepted and within two years she had become Brown Owl. Six successful years later, Anne decided it was time to set up a new Guide group. Under her leadership, the Guides and Brownies thrived and new premises were needed. With the help of friends and parents she was able to raise enough money to buy a hut and have it erected on land next to Tottington Road Methodist Church. In the succeeding years hundreds of girls joined the group, either as Brownies or as Guides. As Anne explained, 'Guiding offers an exciting life to young people, an opportunity to socialize, make life-long friends and learn a whole range of skills useful throughout life.'

Although Anne retired as Brown Owl at the age of sixty-five, she is still involved in the movement as a Trefoil Guide. She has been the local District Commissioner on two occasions, Divisional Commission twice, the County Awards Coordinator, chairman of the Trefoil Guild and camp advisor.

## AUDREY BROWNE
### ONE OF BOLTON'S FINEST

Born in 1928, Audrey recalls that although there was little money in the household, she had a very happy childhood. She attended Wolfenden Street Primary School and each lunchtime would return home via the fishmonger's where she would pick up a fish head for her cat's dinner.

By the age of fourteen Audrey had moved from Halliwell to live in Tonge Moor and when she left school her first job was at Burrells Clothing Factory working alongside her mum making uniforms for British soldiers. When Russia joined the war, she was given the job of making duffel coats for Russian soldiers on the front line. She proudly says that she was the first seamstress to be given this job.

The war over and seeking excitement and adventure, Audrey decided to travel to British Columbia, Canada, where one of her friends had emigrated. At the age of twenty-four and unaccompanied she sailed across the Atlantic and then took a train across Canada to Victoria where for three years she lived in lodgings and worked in a laundry. 'Living on Vancouver Island was one of the most memorable times in my life,' Audrey explained.

Audrey's many interests include music, particulary singing in local church choirs. Among her favourite singers are Renee Fleming and Jonas Kaufmann.

## ANTONIA SOTGIU
### OPERA SINGER

With an Irish mother and Italian father, Antonia believes her singing talent comes from the Irish side of the family. Her mother was one of thirteen children and singing was invariably enjoyed at family parties. Nevertheless, Antonia's first interest as a teenager was netball rather than singing and it wasn't until she was in her early twenties that she decided to study seriously after she had seen a television programme about Amanda Roocroft, the opera singer born in Coppull, Lancashire. Encouraged by her Irish grandmother, a music teacher, Antonia applied for a place at the Royal Northern College of Music and, despite singing a piece unsuited to her voice at the audition, won a place. Seven years of study followed – four as an undergraduate, two as a post graduate and an intensive year at the National Opera Studio in London. For that final year Antonia was fortunate to secure sponsorship from Sir Peter Moores of Littlewoods and the Glyndebourne Opera, where she had appeared in the chorus.

After graduation Antonia worked with the Welsh National Opera touring in a production of Carmen, one of her favourite roles. Her other roles have included Annina in Der Rosenkavalier, as Olga in Eugene Onegin and Suzuki in Madama Butterfly. Among others, engagements with the English National Opera, Opera North, and the BBC Proms followed, as well as seventeen sellout performances as Carmen at the Royal Albert Hall with Raymond Gubbay Productions. On one famous occasion Antonia appeared on stage with a leg in plaster, coloured red to match her dress, following an accident playing netball.

Nowadays Antonia teaches at the Royal Northern College of Music and assists students with the development of their audition techniques. Her ambition to perform has not disappeared however, and she intends to do more. Antonia describes Bolton as 'wet, rainy, and friendly' and has missed that friendliness when she has been away. She feels that Bolton people are straightforward with no 'airs and graces'. Her 'family support system' is based in Bolton and her children go to local schools.

# FACES OF BOLTON

## BARRY MASSEY
### PUBLIC SERVANT AND ENTERTAINER

*When Barry was eleven his mother decided he should learn the trumpet and it wasn't long before he became the first solo cornet player with the Smithills School Band. He still plays today. Like many teenagers Barry was very shy, but he reluctantly took a place in the chorus for the Victoria Hall Youth Group's production of* Babes in the Wood. *However, when one of the principals left suddenly, Barry became the obvious choice – a good one as it turned out, since he has been performing and directing ever since. Having caught the acting bug, Barry has performed on many stages during the last fifty years, including the Victoria Hall, Bolton Little Theatre, with the Phoenix Theatre Company and the Marco Players.*

*Although Barry is mainly known for his comedy roles, he believes his 'finest hour' was when he was nominated for best actor in the Manchester Amateur Drama Awards for the lead in the psychological drama* Night Must Fall. *In recent years Barry has also become well known as a school crossing officer outside Bolton School. Barry says Bolton people are the nicest, and the town is remarkable for the great number of amateur theatre and operatic groups it has spawned.*

## BILL MORGAN
### A LIFE IN LEATHER

*Bill describes himself as the last tanner in Bolton. His company employed over 1,300 people in the town at its peak. A native of Ayr, Bill started work with W and J Martin, leather manufacturers, in Glasgow. When the company came together with Walkers in Bolton in 1958, Bill was sent down to ensure that leather for shoes and furnishings met the required specification. Bill's first impression of Bolton was the beauty of its surroundings and the friendly people. He made Bolton his home, while always being keen to represent Scottish values and ways to Boltonians. In time, Bill became the managing director of the Bolton tannery, although later difficulties within the group as a whole forced the firm to cease trading. Ever resourceful, Bill decided to acquire part of the company to manufacture dog chews from leather. Superior Pet Products became a leading manufacturer, not only within Britain, but also internationally. Like other leaders in local industry, Bill found the time to become involved in the local community. Early forays into amateur dramatics were followed by becoming chairman of Round Table and president of Rotary, as well as chairman of the governors at Clarendon Street primary school.*

# FACES OF BOLTON

## BILL ROGERS
### AUTHOR

'Read, read, read. Write, write, write.' This is the advice offered by Bill Rogers, author of over a dozen bestselling detective stories, to any budding writer.

Bill moved north at the age of twenty-two to take up a teaching post and he says 'I fell in love with Bolton, the place and its people.' From teaching, Bill moved into the education inspectorate, eventually becoming Principle Education Inspector for Manchester City Council. This job brought him into contact with the Greater Manchester Police and this involvement, his knowledge of Manchester and the fact that there are four generations of policemen in his family meant only one thing: when he retired Bill would write fictional detective stories. So Detective Chief Inspector Tom Caton was born. Many published books on, Tom is still solving murders in and around Greater Manchester. 'Tom is the person I would have loved to have been,' Bill says. The books are so popular that he has a bit of a cult following and has now published a book of walks that will take you around Manchester, including Rivington to visit the locations of the various murders recorded in his books.

Bill has been a lifelong supporter of Bolton Wanderers and has been a season ticket holder for many decades.

## BLAKE WARDLE
### PHOTOGRAPHER

He may be only eighteen years old, but Blake Wardle is already demonstrating that he is an extraordinarily good photographer. Since the age of fourteen, Blake has been developing his skill as a wildlife photographer and, in particular, photographing British birds. He recalls the day that his grandad took him for a walk along the Leeds Liverpool Canal near Chorley. His grandad brought along a small compact camera which he gave to Blake to use and that was the start of what is already an amazing career.

Blake joined Bolton Camera Club in 2012 and was the youngest member. With advice from club members his talents in photographing birds and animals developed and he was soon winning club competitions.

His competence was further demonstrated when at the age of seventeen Blake was awarded the CPAGB by the Photographic Alliance of Great Britain. To achieve this award Blake had to submit a portfolio of ten images, each of which is scored up to a maximum of thirty marks. Blake's total score was an amazing 241 marks. Further success followed when he became the Lancashire and Cheshire Photographic Union Young Photographer of the Year 2016.

If you would like to see Blake's work, then just go to www.blakewardle.com.

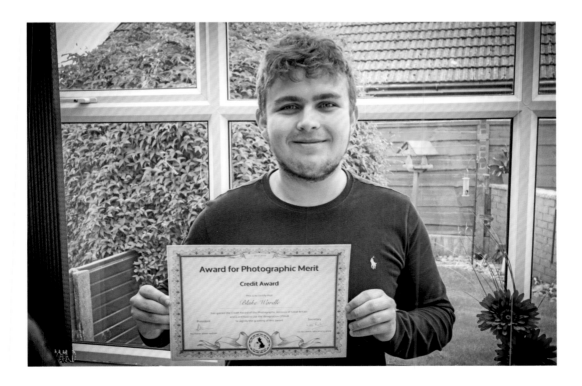

# FACES OF BOLTON

## BRIAN PILLING
### NEWSAGENT'S ASSISTANT

*In the 1970s Brian had his own business as a TV retailer on Blackburn Road selling, installing and repairing TVs. Rental TV also became popular, not least because televisions often went wrong in those days and customers valued the security of a good repair service as part of the deal. As an avid supporter of Bolton Wanderers, Brian supplied televisions to the football ground and advertised on the side of the pitch. Eventually however, the nature of the TV business changed and, following some health problems, he took a job as the maintenance man at St Catherine's Care Home in Horwich, a position he thoroughly enjoyed for ten years. After retiring from the maintenance job, Brian was not going to take things easy. Instead he volunteered as a driver, taking patients to Bolton Hospice, and can also be found most days working at the newsagents near the Beehive roundabout in Lostock.*

*Brian sees himself as a Farnworth man, a town with friendly neighbours and a good social life. Once, Farnworth had no fewer than five cinemas. Today, living in Lostock, Brian thinks he is very lucky to be so close to lovely countryside, being particularly keen on the Rivington area.*

## CHANDRAKANT (CHAN) PARMAR
### BOLTON INTERFAITH COUNCIL

*Chan Parmar was born in Kenya and was living in India when, in the late 1960s, his family decided that Chan would prosper better if he moved to England. Settling with an uncle in Bolton, Chan has been able to give strong support to the idea that people of all faiths and cultures can coexist and cooperate to produce a good society. He enjoyed meeting a wide variety of people while working in local supermarkets and with Age Concern and built on this by becoming a representative of the Hindu community at interfaith meetings in Bolton. This led to him becoming the strategic officer within the Bolton Interfaith Council in 2006, a position that Chan clearly relishes. He is enthusiastic about the council's commitment to peace, harmony, the building of trust and the breaking down of barriers between communities. He believes that people should be able to develop a strong feeling of belonging in Bolton and that an understanding of our various histories will help in this. Chan sees Bolton as a very peaceful and friendly town where all the communities are making their contribution. He particularly applauds the way in which young people have come together as ambassadors for the town.*

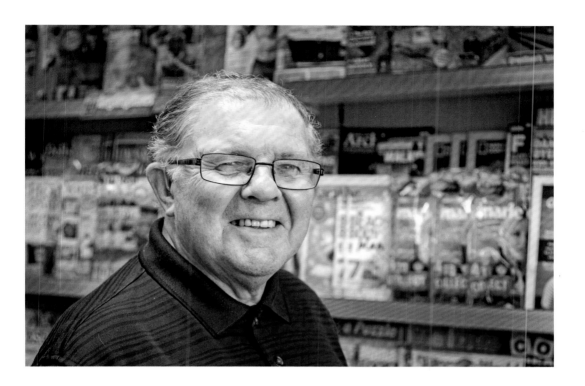

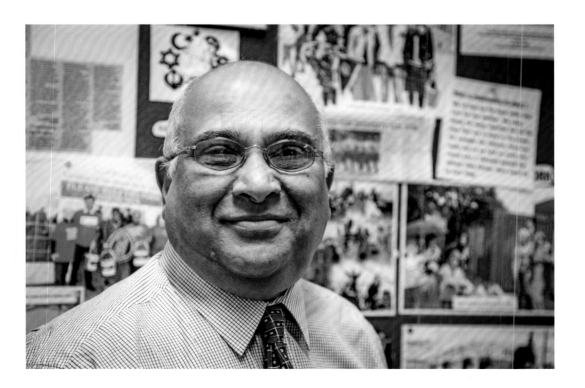

## BRIAN WHITE
### TRAVEL PHOTOGRAPHER

*Although very much rooted in Bolton, Brian has always wanted to travel the world. Today this has resulted in a life alternating between long-distance travel to observe and photograph people and wildlife, and time back in Bolton to share his experiences. When lecturing, Brian has an appealing enthusiasm and knowledge, which are a perfect complement to his superb photographs.*

*On leaving school, Brian became an apprentice with local engineering firm Kemax Tools. His dad was an engineer and his brother an engineering draughtsman at Wadsworth Lifts, so that appeared to set the pattern for the future. However, the determination to travel set in soon after serving his time. Early explorations in Spain, the North African coast and Europe led to a determination to see further places and, in 1981, Brian asked his employers for a sabbatical so that he could travel to Kathmandu by double-decker bus. However, the recession hit soon after, and the firm closed. With that, Brian's link to engineering was severed for good. After taking a course in photography at Bolton College Brian made a trip up the Nile to Lake Victoria. As with all his subsequent journeys, Brian travelled frugally and light, with the aim of getting closer to the essence of the countries he has visited. Excursions to Africa, India, the Far East, Sri Lanka and Central America followed. As the expeditions have progressed Brian has become more focused on investigating particular themes and events. Examples include the depiction of the people of the Mekong River, tigers in India and Nepal, the Zulu wars in South Africa and the upper reaches of the Amazon, Bolivia and Peru.*

*Brian is always pleased to return to Bolton, which he sees as a resilient and friendly working-class town that has come through difficult times, as first the cotton industry, and then industry in general faced major contractions in the second half of the twentieth century. The people are still the same however, and Brian says he is determined to stick around.*

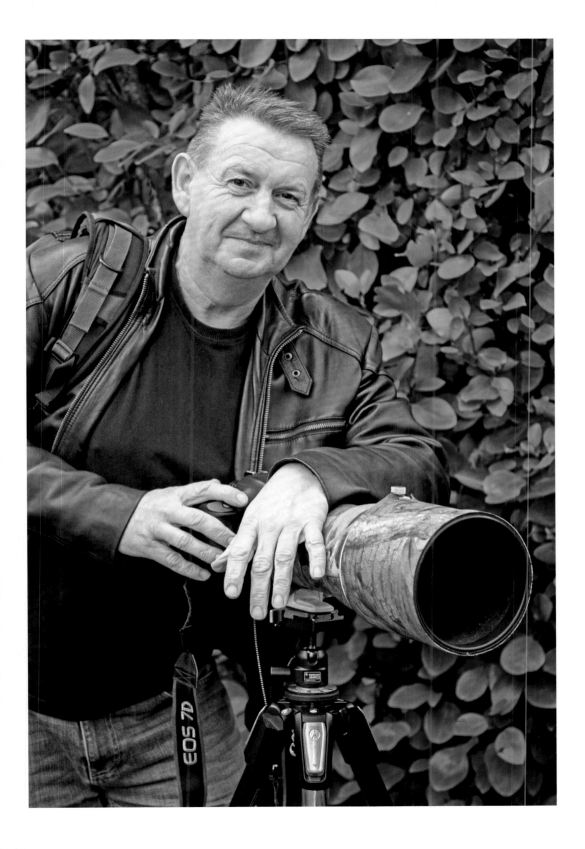

# FACES OF BOLTON

## CHRISTOPHER BROOKS
### DENTIST

*Graduating as a dentist in the early 1980s, Chris particularly wished to remain around Bolton. Initially however he had to be content with joining a practice in Preston. That was towards the end of the era when gas and air were administered for some dental procedures – a practice that stopped in the 1990s. Eventually Chris was able to acquire his own surgery, initially sharing with another dentist in Chorley New Road. He had achieved his ambition to locate in his home town, and took the opportunity to build and expand his practice over the years as well as serving on the local NHS dental committee. In recent years, the regulatory requirements for dentistry have increased (rightly so in Chris's view) and this has led him to join with a national organisation, Oasis Dental Care, to secure the future.*

*Chris feels that Lancashire is often misunderstood by people who have not spent time there, stressing the beauty of the Forest of Bowland and the Ribble Valley, as well as the sheer variety of cities, towns and coastal areas. He is also impressed by the fact that Bolton has more cricket clubs per head of population than any other town in the world.*

## DAVE JOLLEY
### TOWN PLANNER

*Dave's great-grandfather was one of 344 miners killed in the Pretoria Pit disaster in 1910 at Over Hulton, Westhoughton. Interesting in itself, this was poignant for Dave when he became involved in coal extraction proposals in the area later in his career. For nearly thirty years Dave worked as a town planner with Salford City Council but has lived in his home town of Bolton. As well as helping to establish the Blackleach Country Park to the south of Farnworth, he became involved in the Lomax open-cast coal extraction scheme and also helped tackle the large Cutacre project on the boundary between Salford, Wigan and Bolton, involving coal extraction and the development of the major employment zone and distribution centre. When Salford formed a partnership with CAPITA to provide development services to the city and other local authorities, Dave led the town planning element, growing the workload right across the country.*

*Outside work, Dave is a keen fell walker. He likes to describe Bolton as an historic town located in the hills of the Pennines. He points out that the town centre has some superb buildings, is very pedestrian friendly, and wherever you are you can see the surrounding hills.*

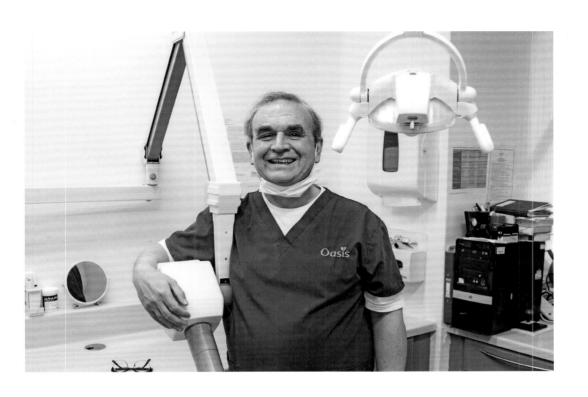

# FACES OF BOLTON

## DAVE BAGULEY
### CHIEF EXECUTIVE, URBAN OUTREACH

*A few minutes late for the interview, Dave said: 'So sorry, I've been collecting food, fresh vegetables and fruit from one of the local supermarkets where I'm known as "Mr Charity"; they'll make some great soup and pies for our clients at Winterwatch.'*

*Dave is known to thousands of local people as the Chief Executive of Urban Outreach, a Christian charity that works to provide a better quality of life for disadvantaged, abused and homeless people in Bolton. 'Although there is poverty in Bolton, the way that local people respond to calls for help is phenomenal. Whether it's the supermarkets, churches, schools or individual volunteers, they are all wonderful and this is what makes Bolton great.'*

*Dave first came to Bolton in 1998 while training with British Youth for Christ. That's when he fell in love with the town and its people and, shortly after, he met Chris who was to become his wife. Together they set up Urban Outreach, which has gone from small beginnings, helping young people in various types of difficulty, to a significant organisation that now operates a broad range of projects, some multi-agency. The best known is Winterwatch which, with the help of volunteers, provides wholesome meals to the homeless and those in need. This project is supported by supermarkets, churches, schools and individuals, who provide food at no cost to Urban Outreach. Dave is immensely grateful to those who give and those who volunteer and to the agencies that provide financial support and expert advice, particularly Bolton Council.*

## WARWICK MILNE
### CRICKET SUPPORTER, PLAYER AND ADMINISTRATOR

*Warwick says an obsession with cricket is an illness for which there is no cure. While at Bolton School, he captained each of his year teams. Although he is willing to play almost any sport, cricket has been his main preoccupation outside work. Warwick joined Heaton Cricket Club in the 1970s, played all he could and became captain for the first time in 1979. He has also been the secretary and general organiser. He is proud the club has some of the best facilities in the Bolton league.*

*He believes sport teaches vital life skills such as volunteering, competitiveness, communication and respect for others. As a chartered accountant, Warwick uses his financial skills working with the Salford Red Devils rugby league team, where he enjoys tackling the many regulations and requirements of the modern sporting world.*

*Warwick is passionate about Bolton, where industry, self-sufficiency and pride in the town is commonplace. The number of amateur sporting opportunities in the town is extensive – running, cycling, tennis, rugby, cricket, football are all readily available and have fantastic spin-offs. Bolton has a beating heart for sport.*

## DAVE EVITTS
### GREAT BRITAIN DEVELOPMENT COACH FOR PARA SWIMMING

*Fewer people can have had a greater influence on the sporting achievements of local young people than Dave Evitts. Dave has dedicated the greater part of his life to coaching youngsters in swimming and can claim some credit for the success at international competition of many of Bolton's finest swimmers. In his youth, Dave was himself an outstanding swimmer and, trained by his dad, Brian, he succeeded in winning several national championship gold medals.*

*His early ambition was to be a police officer, and this ambition was fulfilled when, at the age of sixteen, he was accepted as a police cadet. He recalls that during this time he helped the Greater Manchester Police to beat the Metropolitan Police in the British Police Swimming Championships, much to the delight of the then Chief Constable, James Anderton.*

*At the age of twenty one, Dave retrained as a swimming coach and in 1993 he gained the post of Sports Development Officer at Bolton Council, his job being to establish Bolton as a centre of swimming excellence. This led to the creation of Bolton Metro Swimming Club. Within twelve months, and with the support of ten coaches, there were over 130 youngsters training up to six times a week, and within a couple of years twenty-eight swimmers were competing in the national swimming championships.*

*In 1998, Dave was appointed a Commonwealth Games coach for England and in 2000 he travelled to Sydney as a support coach to the British Olympic team. His biggest challenge came in September 2012 when he was invited to become a Great Britain coach with the Para Swimming Team. Working with young people with numerous disabilities, his job was to support them and their coaches in their preparation for participation in the Rio Olympics. Dave spent thirty-five days in Rio and for him those days were the most satisfying time in his coaching career.*

*Dave still finds time for his favourite pastime, supporting (in his opinion) the best soccer team in the world – Bolton Wanderers. He has been a season ticket holder for forty years. He is also an avid Status Quo fan, having been to thirty-two concerts.*

# DAVID WHITNEY
## FILM DIRECTOR

*David moved to Horwich at an early age, attending Horwich Parish Primary and then Rivington and Blackrod schools. It was while at Rivington and Blackrod that David developed an interest in film-making. Encouraged by his father, he made his first film while still only aged eleven. At sixteen David went to University College Salford to study Media Production, after which he worked for several independent film companies, working his way up from runner to film director.*

*One of David's early achievements was to direct the making of a film in Afghanistan for Sky TV. Unfortunately for David, when the time came to return home, he and his team found that the local airport was shut due to the assassination of a local politician and this left them with no alternative but to drive through the Khyber Pass into Pakistan, a journey of several days, which he described as 'scary'.*

*In 2005, David made his first feature film,* Taken Out. *Produced locally and self-funded, the making of the film led to him being nominated for the BBC 'New Film-Maker of the Year'. His next film,* George's Boy, *shot in Bolton and starring Michael Byrne, won David the Best Film Award at the Time Festival in Switzerland.*

# DENNIS HOBSON PHD
## RETIRED MAGISTRATE

*A pupil of Manchester Grammar School, a teacher at Eccles School, a lecturer in Emulsion Polymerisation at Salford College of Technology and at Manchester Metropolitan University, Dennis has demonstrated a wide range of academic achievements throughout his long professional career. However it is as a magistrate that he is better known in Bolton.*

*While working as a heating consultant, it was suggested to Dennis that he would make an excellent magistrate. His application was successful and with the blessing of his employer, who gave him time off from work, he commenced his duties in the Bolton Magistrates' Court in 1986. He worked in the Youth and Family courts before becoming the Deputy Chair and then the Chairman of the Bench in 2002, retiring in 2006.*

*Although Dennis found the work in the courts very satisfying, he explained that 'Going into schools and talking to students about the work of the courts and the special role of magistrates (many students not realising that the work is undertaken voluntarily) has been a very positive experience.'*

*When Dennis retired he became a member of the Independent Monitoring Board at Forest Bank Prison, looking after prisoner rights and acting as an advocate between prisoners and the governor.*

# FACES OF BOLTON

## DOROTHY MARTLAND
### BOLTON COMMUNITY RADIO

*Winner of 'Bolton Woman of the Year' back in 2002, Dorothy has been an inspiration to hundreds of young people throughout Bolton. A teacher at Smithills School for many years, Dorothy has always strived to improve young peoples' skills to give them greater opportunities in their lives. In 1998 she started a charity called Diversity in Barrier-Breaking Communications (DBBC), which aimed to improve the self-confidence of young people through the medium of radio. DBBC offered to young people, many of whom suffered with disabilities, the chance to learn a range of communication and technical skills. The courses that Dorothy devised were accredited by the Open College of the North West and, with the help of Bolton Council (including the use of offices at Bolton Market), she was able to establish a recording studio. The project became so successful that she was awarded a licence to operate Bolton FM Radio, Bolton's first radio station.*

*Although no longer involved in local radio, Dorothy is still engaged in charity work. In 2012 her work with young people was royally recognised and she became a Member of the British Empire (MBE).*

## DOUGIE TOBUTT
### SPORTS INJURY SPECIALIST

*If the thought of running 26 miles and 385 yards fills you with terror and makes you go weak at the knees, then spare a thought for this man. He's run 126 marathons!*

*Dougie Tobutt is the third-generation owner of Tobutt Sports, a high-quality sports equipment store on Blackburn Road, Astley Bridge. As a young boy Dougie was interested in most sports, playing football, cricket and basketball, but his main love was running. 'I remember my mum giving me 2d a day for the the bus fare to school, but instead I just ran behind the bus to Brownlow Fold Secondary School and used the money to buy sweets.'*

*His first long-distance run was in 1981 when he ran the Bolton Marathon. Twenty six years on he is still running marathons and can now claim a total of 126, not only in the UK but across the globe; in fact he has run marathons in over fifty countries.*

*Having suffered numerous injuries himself, Dougie saw an opportunity to help other sports injury sufferers. He went to college, studied sports science and health and fitness, obtained twenty certificates along the way and then in 2006 opened his Good Health Centre above the shop. He sees up to fifty clients a week, diagnosing and treating injuries.*

## DOREEN HOBSON
### A TOUCHING STORY

Doreen was the eighth child born into a family of nine children. During the birth of the tenth child, her mum sadly died. Having to look after nine children was simply too much of a burden for her dad to bear and after only three weeks he committed suicide, leaving all nine children in the care of relatives. Doreen was five years of age at the time and she can recall that one day, with a younger brother and older sister, they were taken by car on what they believed to be a picnic, only to find that the destination was a local orphanage where the three of them were left in a most distraught state. Fortunately for her, but not her brother and sister, a couple seeking adoption came to the orphanage and decided to adopt Doreen. She recalls that when she arrived at her new home she thought she was in heaven. Her new mum and dad were very loving and she never wanted for anything. However, sadly she lost all contact with her brothers and sisters.

After attending Eccles Grammar School, she qualified as a teacher at Edge Hill College and taught for many years in several schools in the local area.

It was by chance that one day she received a telephone call from a friend to say that she had seen an advert in the Bolton Evening News (BEN) seeking information on a Doreen who had lived in Worsley and had been adopted as a child. Doreen rang the BEN to say that she fitted the description and was told that someone called Catherine was trying to find a Doreen. With considerable trepidation Doreen rang the telephone number that she had been given to discover that it was her sister.

What followed was one of the most wonderful and emotional events in her life, a reunion with seven of her brothers and sisters as well as her adopted parents. After being brought up as an only child, suddenly there she was among her long lost  brothers, sisters, partners, nieces and nephews; a huge family whom she had never forgotten and once again were united.

# ELIZABETH NEWMAN
## ARTISTIC DIRECTOR, OCTAGON THEATRE

*A one-year posting to Bolton has turned into eight for Elizabeth Newman. She arrived in the town on a secondment and stayed on to forge a significant role in the Octagon Theatre. She has been impressed by the open and sensitive nature of the people she has met and has a great admiration for the people of Bolton and the artistry that is embedded in its communities.*

*Elizabeth showed exceptional talent as a ballet dancer at a young age. However, she decided to try her hand at theatre directing and gained a place at the Rose Bruford College of Theatre and Performance in Sidcup. Even before she attended college she had directed her first full-length production at the age of sixteen. Then, while studying for her degree, she established a theatre company of her own and ran that for five years. Their productions took them to theatres such as the Oxford and the Salisbury Playhouses and the Albany Theatre. Meanwhile Elizabeth was also cutting her teeth in theatre management at the Southwark Playhouse.*

*Arriving in Bolton in 2009, Elizabeth has been responsible for developing and leading the Octagon's new writing programme. Local writers at all levels have benefitted and several years on, she believes the theatre's writing initiatives have placed the Octagon alongside theatres in Liverpool and Manchester. It wasn't long after her arrival that the Octagon was looking for ways to continue her role in the town, and managed to do that in partnership with Bolton University. As a consequence Elizabeth has been able to bring the university and the theatre much closer together.*

*In 2015 Elizabeth was appointed as Artistic Director to the Octagon. With the Octagon's fiftieth anniversary coming up in 2017, her ambition is to open the theatre out to the local community; to make it the 'peoples' theatre'. In addition a major development is planned to make the theatre fully accessible and adding more space for the involvement of local people, including children in particular. Elizabeth looks forward to these developments to keep the theatre relevant for the next fifty years.*

# FACES OF BOLTON

## ELIZABETH TATMAN
### CHILDCARE SPECIALIST

*Elizabeth trained as a teacher, attending the University of London Institute Of Education. In 1975 she was awarded a degree by the Open University, followed by an MBA in 2001. From 1954 until 1968 she taught at both Bury Grammar School and Bolton School, at which point her career took a new direction as she became involved in early learning and child welfare.*

*A founder member of the Rotary Club of Bolton Daybreak, she became its president in 2001. Through Rotary she has been able to use her skills and experience to train staff in childcare at the Santa Maria Children's Hospital in the city of Iasi, Romania, where she also established their first toy library. Rotary has recognised Elizabeth's achievements by awarding her the Rotary Citation for Meritorious Service.*

*Among her many achievements are being the chair of Bolton Little Theatre from 1998–2003 and again from 2010–15, director of Smithills Hall and Park Trust 2001–07, chair of the Bolton Festival 2000–06 and she is currently the chair of Bolton Arts Forum. In 2010 she was awarded an honorary doctorate by the University of Bolton.*

*Elizabeth's outstanding achievements were recognised in 2013 when she became a Member of the British Empire for her contribution to children and families at a ceremony conducted by the Prince of Wales.*

## FRANK COX
### HIGHWAY AND CIVIL ENGINEER

*Nowadays the firm of George Cox and Sons is a major company in highway construction and maintenance, but it wasn't always that way. Frank Cox, the son of the founder, took a modest paving business and transformed it into a significant contractor to local authority highway departments and others. Yet, in spite of the energy and time this required, Frank has also made significant contributions to Bolton's community life.*

*During his National Service Frank settled as a radar operator in Norfolk where he was able to take up cricket, football and motorcycle racing in his off-duty hours. On returning to civilian life, Frank joined the family business in Bolton, and eventually became its prime mover. Cricket continued to feature, playing for the St Osmund's, Breightmet, church team, where he was captain for around ten years. However Frank also become involved in local societies, including the Bolton Catholic Operatic Society (where he was chairman), the Bolton Cricket Club (again, Frank was chairman) and the Bolton Bridge Club. Frank says he couldn't leave the Bolton area, being particularly impressed with the way in which so many communities and organisations are blended together.*

# FRANK WHITE
## POLITICIAN

Frank was evacuated to Bolton during the war and he ended up staying. Working at de Havilland's, he found that he was good at negotiation, and his ability to relate to people has clearly served him well throughout his life. Elected as a councillor for Tonge in 1963, the Borough Council was his main focus until he became the Member of Parliament for Bury and Radcliffe in 1974, serving as PPS to the Minister of State for Industry. After nearly a decade in parliament Frank was appointed chief executive of the Lancashire Property Development Association and, subsequently, the director of the National College of the General and Municipal Union. Frank was chairman of the Bolton Magistrates from 1992 to 1995. On retirement in 2009 he was the longest-ever serving magistrate in England. Since 1986 Frank has devoted himself to being a councillor once more, including being chosen as Mayor of Bolton. Frank says that being Mayor lifted the lid on everything that is good about Bolton. Over the years he feels that what is known as the 'Bolton Way' has been key – a tolerance of a wide range of viewpoints and a determination to involve the whole community in shaping the future.

# JAMES FREDRICK HORRIDGE
## RETIRED STRUCTURAL ENGINEER

Fred is an amazing ninety-two-year-old local man whose only claim to fame when he left school back in 1938 was a certificate for swimming 25 yards. He still has the certificate, of which he is very proud. School never interested Fred, so when his dad told him to 'Go find a job', Fred reluctantly obeyed and got himself a job labouring at Watson's steelworks. However the war put a stop to his ambitions as he was called up and served for the last couple of years of the war in the Royal Navy.

Upon discharge Fred got a job as a trainee draughtsman, went to night school and never looked back. He moved into structural design and eventually became chief designer and later the general manager of Lowton Construction in Leigh. This was followed by him becoming a part-time lecturer in structural theory at Bolton Technical College. He obtained an MSc. at Manchester University, although he says 'It was really useless to me as I was already a chartered structural engineer and had a good job.'

Fred is an accomplished musician; in his youth he played the clarinet in local clubs and he can remember winning a Melody Maker contest at Bolton Palais. His other claim to fame is that he wrote the Stockport County Football Club supporters' song.

# FACES OF BOLTON

## GANSHYAM PATEL
### OF THE SHREE SWANIMARAYAN MANDIR TEMPLE

*Ganshyam was still a teenager when his family was expelled from Uganda with only ninety days' notice. Luckily Ganshyam could speak English and he was able to obtain work, first making travel cases, and then becoming a worsted spinner in Bolton. Following studies at Bolton College and Bolton Institute of Technology he qualified as an Associate of the Textile Institute and rose through the company to become the production manager. Following a management buyout in 1990 Ganshyam decided to devote his time to the family newsagent business, which has grown and diversified over the years. In around 1984 Ganshyam became closely involved with the Swaminarayan temple. He helped build it up, and particularly remembers a carnival in 1992 when they hosted a visiting priest from India. Around 1997 the temple was offered first refusal of their current building, a former Unitarian Church. During the next few years improvements and expansions took place and, today, a congregation of up to 300 is quite normal. The temple runs sporting teams, mounts yoga classes as well as playing host to a Scottish pipe band. Ganshyam likes the friendly, welcoming and more relaxed atmosphere in Bolton compared to London, where he has family.*

## HARRY GRUNDY
### FISHMONGER

*Think of Bolton Fish Market and for most people the name Harry Grundy will spring to mind. For many years Harry was the face of the fish market. If you wanted quality and variety then it was to his stall you went. Always a smile and a word of welcome, Harry was there to advise and of course fillet the fish for you. Although he has now retired from the fishmonger business, the family name can still be found in the fruit and vegetable section of the market.*

*Born with Potts Disease, a form of tuberculosis that affects the spine, Harry was confined to hospital beds for much of his early years as medical staff attempted to minimise the curvature to his spine. However Harry has never allowed his disability to affect his life and as well as being a successful businessman and family man, he still enjoys helping others through his charity work. Harry uses his boundless skills to raise funds for numerous local and national charities including Pets in Need, the Dementia Support Group, his local Rotary Club and, for over twenty years, students of the Northern School of Music through his annual charity Opera Evening.*

## GILLIAN PLATT
### FLOWER ARRANGER

Gillian was born during the Second World War, the middle of three girls born to Lena and John Haslam. On leaving school Gillian gained her first employment in Kendall's department store in Manchester where she served a three-year apprenticeship in hair dressing before moving on to become a fully qualified hair stylist.

One of Gillian's greatest loves is choral singing, having from the early age of fourteen performed a vast array of choral works, mainly at her beloved Methodist church in Harwood where she has worshipped since being a baby in her mum's arms. Having received professional singing lessons from the late Margaret Collier, Gillian is proud of the fact that she once appeared in a choir on television.

A love of flowers inevitably led to her joining locally run flower arranging classes, and from that simple beginning Gillian became a member of NAFAS, The National Association of Flower Arranging Societies. As a member of NAFAS she held numerous positions, starting as the social secretary of the North West branch, then moving on to become the 2nd vice chairman, 1st vice chairman and in 2001 the Chairman. Her talents with flowers did not go unnoticed and in 2012 she was appointed national President, a position she held for two years.

Her many achievements as a member of NAFAS include arranging the flowers at Westminster Abbey on the occasions of the Queen's Golden Jubilee, the Queen and Prince Philip's Golden wedding, the Queen Mother's funeral and the memorial service for Nelson Mandela.

Gillian's story does not end here, as she can proudly say that she has been a magistrate in Bolton for thirty-two years, serving the community of Bolton in the Crime court, Youth court and Family court.

Gillian still continues to teach flower arranging, holding adult classes each month at the Longsight Community Centre and junior flower arranging classes, again monthly in Harwood Methodist Church Hall.

As recognition of the contribution to floral art and the local community, Gillian was appointed a member of the British Empire (MBE) in the 2016 New Year's honours list.

## IBRAHIM KALA
### BOLTON COUNCIL OF MOSQUES

*Ibrahim describes himself as 'born, bred and buttered' in Bolton. Yet his family is one of perhaps 300 living in the BL3 area who have their origins in Barbodhan, a village in Gujarat, India. After graduation Ibrahim worked within the equality and diversity team in the town hall. This led him to become the first black director of the Bolton Racial Equality Council. Building on this experience, Ibrahim was invited to be the chief executive of the Bolton Council of Mosques. His role is to be a conduit between the community and local statutory bodies and to offer a meeting place for groups covering such issues as mental health and support for young people. In that latter sphere Ibrahim is proud to have been involved with the first Asian football team launched in Bolton in the early 1990s. He was also particularly pleased to be asked to be the first Mayor's Chaplain from the Muslim community.*

*Ibrahim feels that Bolton has changed in recent years, with a wider variety of people now migrating to the town. He believes they will be welcome in Bolton and that immigration can be made to work for the benefit of Bolton and the country.*

## JACKIE AND KEITH HORNER
### HAIRDRESSER AND DESIGN ENGINEER

*Keith and Jackie, who first met when they were at Deane Grammar School, both exhibit a hard-working entrepreneurial spirit. Jackie's father had a number of businesses in Bolton himself, including the former Majestic service station on St Helen's Road. Jackie decided early on that she wanted to be a hairdresser and while attending college also ran a mobile hair and beauty service. Her wish to give a fully professional, customer-centred service eventually led the opening of a salon on Chorley Old Road. Around thirteen years on, commitments with family and friends led Jackie to scale back her career as Keith's activities expanded. He had started as an apprentice dealing with lubrication systems, but also sold prawns and cockles in Farnworth and Westhoughton pubs in the evening. Helping to grow the lubrication company, Keith eventually became a partner and director. In due course the opportunity came along to buy another company in the same field and Keith found himself working away in Cheltenham. Again, Keith built the company up and sold it on, although this also led to worldwide travel with the new owners. Today Keith has founded a new company in the Bolton area with a new partner to lubricate commercial baking equipment.*

# FACES OF BOLTON

## JANET DARWELL
### CYCLIST AND WALKER

*Janet's cycling became serious when a neighbour's children asked if they could cycle with her to Southport. They achieved their objective, but, unsurprisingly, decided to return by train. Nevertheless, the seed was sown. When her mother, Vicky Leyland, died Janet and her brother decided to organise an annual road race in her memory. Vicky had been an excellent marathon runner and the Vicky 10 road race for charity was born. To promote the idea Janet and her brother cycled from Land's End to John O'Groats. Over the next nine years Janet promoted the races by cycling to events around the region. The awards ceremony took place at the British Aerospace factory where Janet's mother had worked as a secretary. Janet has always loved the countryside and thinks the scenery in the North West is stunning. This stimulated her interest in cycling time trials. In the twelve-hour event Janet held a women's course record for five years with a distance of 224.6 miles. She has also competed several times as an Audax UK long-distance cyclist over 200 km. In recent years walking has also featured, including two pilgrimages to Santiago de Compostela in support of the Fort Alice refuge in Bolton.*

## JANET SWINDELLS
### HEALTH VISITOR

*Although Janet has travelled extensively, she has always found her way back to Bolton. She trained as a nurse at Bolton Royal Hospital and loved getting to know the patients. Even before she was twenty Janet travelled as a nurse to Israel, Egypt and Cyprus. Returning to England, she trained as a midwife, although this did not cement her future career. Her then partner was a merchant seaman and this led to further travels, although not of the luxury, tourist kind. She witnessed acute poverty and corruption, nearly starved in the Sudan (where even the rats abandoned the ship), and experienced some of the roughest seas in living memory during a trip to Venezuela.*

*After this Janet decided to take up public health nursing. Today, Janet is a team leader, helping families to maintain optimum health, positive attitudes and good parenting. She speaks firmly about her love of Bolton, believing that it should certainly be a city. She points to the value of the diverse communities and the vibrant student population. Given its location and history, there is the potential for future growth and also an opportunity to bring people closer together in a celebration of Bolton's place in the world.*

# FACES OF BOLTON

## JEAN GERRARD
### LOCAL HISTORIAN

*If you ever want to know something about the history of Turton, then Jean Gerrard is the person to speak to as she is a mine of information on the history of Bradshaw, Harwood and Turton. Jean has lived all her life in the Harwood area. She was educated at Bolton School and she recalls that Ian McKellen was at Bolton School at the same time.*

*Jean trained as a teacher and came back to Bolton to teach home economics at Breightmet Secondary School. She then taught at Turton Harwood Methodist Infants School, and was soon to become the deputy head of the renamed Longsight County Primary School. On one occasion she took a large group of children to London to visit Pudding Lane, where the Great Fire of London started back in 1666 and coincidentally on their way back, Kings Cross Railway Station caught fire, which caused great alarm for the parents back in Bolton.*

*Jean retired in 1990, which allowed her to devote more time to local history and to the Turton branch of the Civic Trust. Jean is also chairman of the Turton Local History Society. 'The Society has a thriving membership of over forty members and we meet monthly at the community hall on Longsight, Harwood.'*

## JIM HOLLYMAN
### PROMOTER OF FAIRTRADE

*Jim Hollyman has been a prime mover in Bolton becoming a Fairtrade town. Born in south Wales, Jim started as an engineering surveyor, but after a few years felt a calling to the ministry and studied theology at London University. He came to Bolton in 1984 as the minister at St Andrew and St George United Reformed Church in St Georges Road. Although he retired in 2001, Jim wanted to stay in the area and he soon became the coordinator of the Bolton Fairtrade group. A campaign was launched to persuade retailers and restaurant owners to offer Fairtrade products, including stunts such as the display of a double bed on Victoria Square with local councillors Bob and Barbara Ronson installed, separated by a human banana. In 2003 Bolton Borough Council passed a supporting resolution and the accreditation of Bolton as one of the first Fairtrade towns was possible, the significance of which has grown over the years. Jim describes Bolton as 'the human face of Manchester'. He says that Bolton is less frenetic and friendlier, with a down to earth, working background. He also believes that community relations in Bolton are way ahead of other similar places with ethnically diverse populations.*

# FACES OF BOLTON

## JOHN BURN
### PAEDIATRICIAN

John Burn has devoted his whole working life to the care and wellbeing of children in Bolton and the North West. The son of Dr Lance Burn, Medical Officer of Health for Salford from 1941 to 1968, John was educated at Salford Grammar School before following in his father's footsteps by studying medicine at Manchester University. He won first prize for surgery, which helped him obtain his first appointment at Manchester Infirmary where he met Anne, a nurse, who was to become his wife. They have been married now for over fifty years.

His inspiration to become a paediatrician came from Professor Aaron Holzel, who encouraged John to train in the field of children's medicine. His training took him to the Royal Manchester, Pendlebury and Birmingham Children's Hospitals. In 1973 John became a consultant and moved to the Bolton Royal Infirmary where he worked in paediatrics for thirty years before retiring. However John has continued to work in community paediatrics on a part-time basis, offering his services to hospitals throughout the North West caring for chronically disabled children. John has also worked as an expert witness in numerous major legal cases and is regularly consulted on matters relating to the safeguarding of children.

## JOHN CARR
### PROPRIETOR, CARRS PASTIES LTD

John Carr and his family have been feeding the people of Bolton for well over sixty years. The business started during the Second World War when pasties made by John's parents, who both worked in the local mill, were sold in his grandparents' UCP Tripe Shop on Halliwell Road. In fact the shop is still owned by the Carr family and is one of its four retail outlets. They can also be bought in over one hundred other local retail outlets with pasties and pies being delivered daily so that they are always fresh to the customer. Today the business employs seventy-three full-time staff and they produce in excess of 40,000 pasties each week.

John puts the success of the business down to the commitment of all his staff and to the freshness of the produce used. 'All the meat, potatoes and cheese used in the pasties are sourced locally and we insist on freshness and good flavour', John explained. 'The pasties are filled hot and quickly frozen to hold in the flavour, which is why they taste so good.' As to the recipes, John explained that they are basically the same as those used by his parents back in the 1940s, the only real difference being that the meat used today is much leaner.

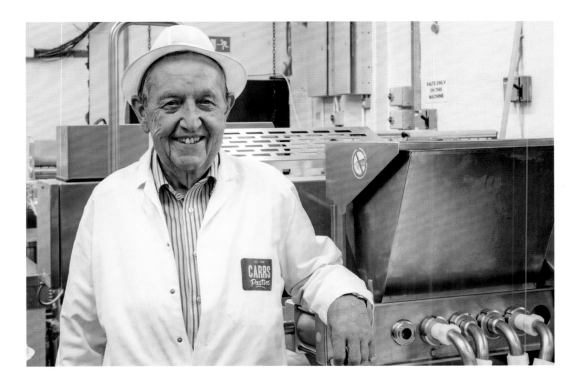

## JOHN SHEPLEY
### A LIFE IN LEISURE

*Brought up in Romiley on the south side of the Manchester conurbation and near to the Peak District, John has always been interested in the outdoor life. His career started in the Forestry Commission, progressing through Manchester City and Lancashire County councils before coming to Bolton in 1974. His professional life encompassed horticulture, landscape design and recreation, with much of his time spent managing Bolton's country parks, open spaces and leisure facilities. John remembers the early days of reclaiming some of Bolton's worst areas of dereliction to create Moses Gate Country Park and the improvement of the River Croal and River Irwell valleys in particular. Organising the Bolton Show in Leverhulme Park, leisure centres, sports fields and, interestingly, the town's crematorium all came within his remit. He was also no stranger to judging rose queens and babies at local shows.*

*Since retiring John has developed a rich vein of voluntary activities. He is a judge for the North West in Bloom competition, is Chair of Governors at Lever Edge Primary Academy and Vice Chair at Sharples Science College. He has been chairman of the local YMCA for a number of years as well as being a prominent figure in Rotary, leading their annual international summer camp project in the North West for young people. Nevertheless, John has always found time to start each day by running several miles before breakfast.*

*John is committed to Bolton. He says that Boltonians are friendly, if sometimes outspoken. He is fascinated by the town's industrial history and how this has impacted on things today. Although the legacy of dereliction and decline of the textile industry has been largely tackled, there are still challenges to face – as with many large towns in the north of England. He acknowledges that the progress of Bolton Wanderers Football Club is a major interest in the town, but also stresses the role of Bolton United Harriers with a long and illustrious history, involving some famous names, such as Ron Hill. Bolton was, he points out, also the original home of the sports shoe company Reebok International.*

# FACES OF BOLTON

## JOHN WALSH
### BORN AND BRED BOLTONIAN

*Politics has been an abiding interest for John from a very early age. In 1975 he was elected to Bolton Borough Council – at the time he was the youngest councillor. In another sphere John has been a regular supporter of Bolton Wanderers since the age of six. When the football club's move from Burnden to their new stadium at Middlebrook was imminent, the directors invited John to become a consultant to the project, which proved an exciting period, being involved in the development throughout. In 2002 John became mayor of Bolton and had a 'fabulous year' involving over 1,700 engagements, the Commonwealth Games and the 750th anniversary of the borough. He is also heavily involved as a churchwarden at Bolton parish church and acts as president of the Bolton United Services Veterans' Association.*

*John believes Bolton is a dynamic place with many good changes over the last thirty years. The town's diverse buildings, nature and demographics give the town its character and distinctiveness. Continuing a long tradition of immigration, many distinct communities are making the borough their home, and John feels that the town is rising well to the challenge of ensuring harmonious relationships.*

## KATH FOSTER
### SALVATION ARMY

*From an early age Kath's ambition was to play the tambourine and she recalls that when she was only eight she took her brother and sister to the Salvation Army, but instead of the tambourine all three of them ended up learning the cornet. At the age of ten Kath became a junior soldier and a senior soldier at sixteen. However by the age of eighteen she had lost interest and spent two years 'Drinking and generally enjoying myself. But God never left me.' By the age of twenty Kath was back in the Army, where she is still actively involved. She carries out numerous roles, including treasurer, Home League secretary, Corps Cadet Guardian, and teacher as well as several fellowship and service pastoral roles.*

*In her spare time Kath loves to sing and dance. She has been a member of a rock choir for over three years and has for as long as she can remember 'walked the line' at the local line dancing class.*

*Kath is proud of what she believes and says she will never shy away from talking about her faith.*

## KAREN ELLIOTT
### FOUNDER AND CHAIR OF BOLTON CANCER VOICES

'Rehearsals are one of the highlights of the week; I always look forward to attending. My involvement has given me positivity, relaxation and confidence: the choir has helped me to centre my world, be part of something brilliant and worthwhile and made me feel happy with life again.' These are just two quotes from members of Bolton Cancer Voices, a choir formed in 2012 by an inspiring woman, Karen Elliott.

Karen, who herself has experienced the effects of cancer in her family, has many years of experience of fundraising for worthwhile charities but felt that she wanted to give her time and talents to supporting local people who were suffering the trauma that comes with a cancer diagnosis. It was one evening while watching Gareth Malone on television work miracles with a group of individuals with little or no singing experience and turning them into a first-class choir that she had a golden moment and realised that she could use her musical talents to create a choir from men and women suffering or who had suffered with cancer. Karen's initial attempts at trying to interest the BBC in her idea failed miserably, so she turned to friend Clive Rushworth who agreed to become the musical director. A small choir of friends and acquaintances was formed and five rehearsals later they gave their first concert.

Today the choir has a membership of over forty people, all of whom have suffered from cancer. Karen hopes that one day the choir will be seventy strong. 'No auditions are required, just come along to the rehearsals and enjoy yourself, you will be made most welcome,' Karen says.

As there is no charge for choir members, all their income has to be raised through concerts and voluntary giving. The choir has received a small grant from the Lottery Fund, but with annual costs of over £7,000, they are always on the lookout for ways of generating income.

If you would like more information then have a look at the choir website: www. boltoncancervoices.orguk

# FACES OF BOLTON

## KATHLEEN BROMILOW
### FLORIST

Kathleen's family had a market gardening business on Austin's Lane, Lostock and in 1955 decided to open a florist's shop on Winter Hey Lane, Horwich – the same shop Kathleen runs today. Over the years the nature of the business has changed markedly. At one time flowers were obtained in Bolton and the blooms available were very seasonal. Early-morning visits to the wholesalers around four days each week were the norm. As time went on Dutch suppliers became important, bringing flowers from a wide international catchment. Nowadays Kathleen obtains most of her flowers from wholesalers in Chorley and is able to place her orders over the internet, although she still likes to put in an appearance at the markets to keep up with friends and colleagues. The range of blooms available has greatly increased, including supplies from Columbia, Ecuador, Italy and Kenya, and the idea of seasonality has mainly disappeared.

Aside from her business Kathleen has an interest in family history and has traced her ancestors back to 1640. Remarkably, many of her forebears have lived in the Lostock area since that time. Apart from a love of Ireland, Kathleen says she wouldn't wish to live anywhere else than Bolton.

## MARK HEAD
### BOLTON CIVIC TRUST AND RETIRED ARCHITECT

Born in Woking, Surrey, Mark studied architecture at Bristol University. Following graduation Mark's first job was with Bradshaw Gass and Hope, the well-known local firm of architects and so started his love affair with Bolton.

Mark recalls fond memories of his early days in the design office at BGH. 'It was before the days of computer aided design. Equipment was a drawing board and wooden T-square and calculations done using a slide rule. It was great fun, the office being a microcosm of society.' However, as Mark explained, 'It was soon to change when under the Thatcher government, minimum fees were abolished and this introduced greater competition among firms. To keep costs down everyone had to work to budgets and deadlines.'

Mark found being an architect stimulating and satisfying. He worked on numerous projects, and in particular hospital schemes, including Hope Hospital (now Salford Royal). In 1992, Mark became a partner at BGH, and later became a senior partner.

Retirement has allowed Mark to join Bolton Civic Trust where he has been able to use his skills and experience to offer advice on redevelopment issues, particularly in Bolton town centre. He is passionate about sustainability and wants to ensure that Bolton's architectural heritage is not damaged by inappropriate development.

## CLLR LYNDA BYRNE
### MAYOR OF BOLTON

*Like many others, Lynda didn't plan a life in politics, although, as things turned out, it has become an important part of her life. As a teenager she had a spell in hospital, where she quickly realised that she wanted to become a nurse. She was accepted as a cadet, known in Bolton as 'primroses' on account of their uniforms. A solid and varied period of training followed, which ultimately led to Lynda working in hospital operating theatres for five years. During this time Lynda met her husband, John Byrne, who has also devoted part of his life to being a councillor in Bolton. Indeed, it was John who took the first step to become involved in local politics, although Lynda was persuaded to follow on and soon became secretary to the local branch of the Labour Party. Perhaps inevitably she was persuaded to stand in local elections and won the Bradshaw Ward in 1994 — the first Labour and female candidate to be elected there. Other wards followed, but for the last thirteen years Lynda has represented her home area of Breightmet where she feels she truly belongs. Lynda has enjoyed a variety of responsibilities with the council and Greater Manchester Fire Service but was particularly involved and interested in the work of the Adoption Panel seeking to ensure the best outcomes for children and their prospective families.*

*Lynda is very proud to be the Mayor of Bolton. Since becoming Mayor she has visited many people and organisations and this has confirmed her view that the town is, above all else, a friendly place. The borough has a lot to offer in its diversity and she is particularly pleased with the wide range of invitations she has received during her mayoralty. In addition, she emphasises the architectural quality of the civic centre, the town's fine surrounding countryside and points to the town's significant history as a textile town in the forefront of industrial history.*

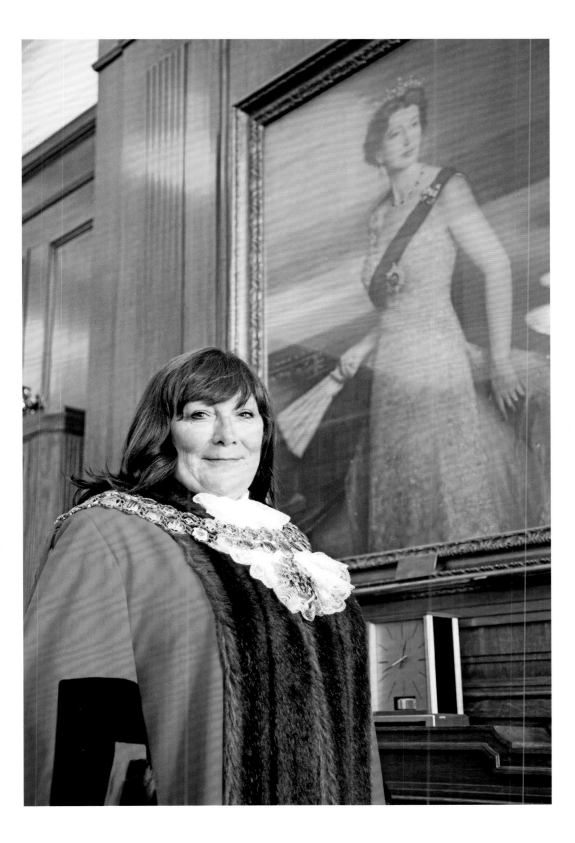

## MARIE WALSH
### PASTIE AND PIE MAKER

Marie Walsh's earliest recollections are of her grandfather's ice cream shop on Bath Street. 'He made all his own ice cream and it was delicious.' At the age of twelve, she moved with her parents to Churchgate to run the Regent Temperance Bar, which was next door to the Man and Sythe. So Churchgate has been her life for the last seventy-odd years.

Although the present pastie shop has only been in business since the 1960s, the building dates back at least to 1667. Following a fire in 1987, architectural historians examined the structure and were of the opinion that it could be even older than the date on the outside of the shop states.

Marie started work in the Pastie Shop in 1961 and it was during the 1970s that she took over the business and turned it into the iconic and loved business that we all know. Marie is proud of the fact that her pasties are made from the same recipe that she inherited when she took over the business. All the pasties are hand-made on the premises. You will find very little mechanism here.

Customers' favourite pasties? Marie says, 'Undoubtedly the meat, potato and onion pastie, although the vegetarian pastie is catching up as people become a little bit more health conscious. It's not only pasties that are made on the premises. All the bread and cakes sold in the shop are also baked here as well.'

Marie has no intention of retiring from the business. 'I love it too much,' she says, although her son does much of the hard work these days. Outside work, Marie lives a full and active life with her husband to whom she has been married for fifty-three years. She is president of the Tonge and District Canine Society, vice president of the National Irish Wolfhound Society, trustee and chair of Vision Aid, she is a fundraiser for Christie's hospital and a member of the Lancashire Cricket Club. On top of all that she and her husband have five Irish Wolfhounds.

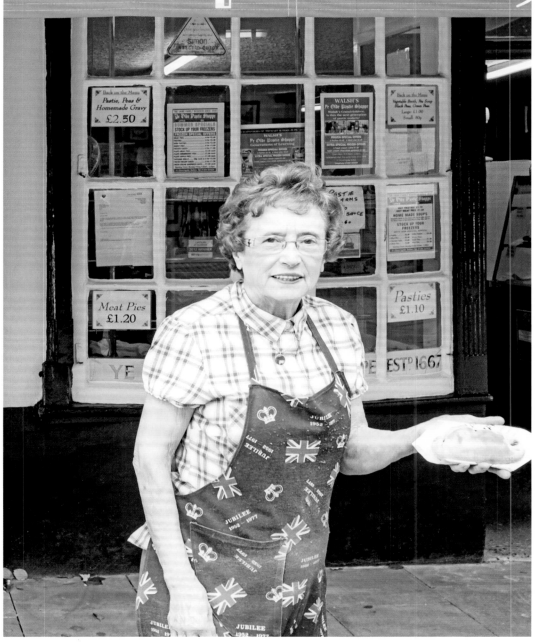

## THE LATE DEACON MARION ASPINALL
### A WOMAN CALLED BY GOD TO SERVE

*Marion Aspinall was born on 24 May 1933, a day that is known by Methodist's worldwide as John Wesley Day. Upon leaving school she trained as a nursery nurse and then as a state registered nurse. A short spell working as a district nurse in Halliwell was followed by a move to the east end of London working at the Salvation Army Mothers' hospital. While in London Marion decided to retrain as a midwife and she recalls that her experiences were very similar to those in the popular series* Call the Midwife *– even down to riding a bike.*

*At the age of twenty-five she travelled to Ghana to take up the position of Sister in Charge of a small hospital in Wenchi. The hospital only had thirty beds, a basic laboratory and pharmacy. There was no X-Ray department or operating theatre and the labour ward was a single bed behind a screen in the 'lying in' ward. Marion explained that she was the matron, midwife, tutor, anaesthetist and, in his absence, the doctor.*

*It was while in Ghana that Marion decided to become a missionary and in 1960 she returned to Britain to train in Birmingham. While there she received an invitation to work in a team undertaking pioneering work in the upper region of Ghana. Marion was appointed 'Nurse Evangelist', which allowed her to continue to use her medical skills as she travelled with the team. She was given financial aid from charities such as Oxfam, Christian Aid, War on Want and UNICEF, which allowed her to establish a mobile clinic to provide basic healthcare.*

*In 1970 Marion decided to train as a deaconess in the Methodist Church, and in 1973 she joined a team ministry at Oxford Road Methodist Church, Leeds. Here she worked with young mothers and elderly people within the local community.*

*Marion returned to Bolton in 1979 to train as a district nurse and was appointed as Community Liaison Nurse at St Ann's Hospice. Marion was the first MacMillan Nurse in Greater Manchester and was awarded the MacMillan Gold Medal in 1989. Sadly Marion died of cancer in 2016.*

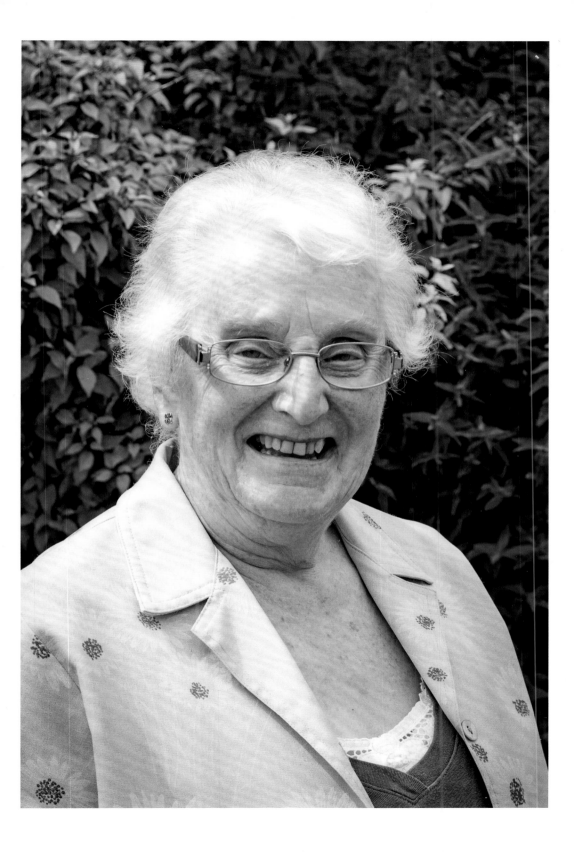

## MARK RELPH
### FUNERAL DIRECTOR

Mark's ambition from an early age was to follow his father into the family firm of undertakers. On leaving school he studied embalming at Blackburn College before qualifying in funeral management at Loughborough College. 'The business has changed considerably since my grandfather, Thomas Relph, started back in the 1920s. In those days the hearse was pulled by horses. Now we have a fleet of limousines, although we can still arrange for a horse drawn hearse if requested.'

Mark says that the most traumatic time in his career was in March 1987 when he was asked at very short notice to assist in the embalming of 193 passengers and crew who died in the Zeebrugge ferry disaster when the Herald of Free Enterprise capsized in the port of Zeebrugge. Mark remembers travelling overnight to work as part of a team to assist in this harrowing event.

Today the business caters for the needs of people of many cultures and beliefs. 'We arrange funerals for Polish people, Ukrainians, Quakers, Jehovah Witnesses, Humanists, as well as mainstream Christian denominations. We have also on occasions interred people on their own property, although to do this we have to comply with strict regulations.'

## MATTHEW WATSON
### CURATOR OF ART AND SOCIAL HISTORY

Brought up in Horwich, as a child Matthew considered a trip into Bolton to be a proper event. He particularly remembers coming to look at the museum's Ancient Egypt and art galleries – places with which he is now intimately involved as part of his work. Matthew was keen on art from a young age and this inevitably led later to qualifications in art, library and museum studies. Stays in Cambridge, Manchester and Oxford followed, although family ties brought Matthew back to Bolton where he joined the Library and Museum Service. He points out that Bolton is fortunate to have a unique combination of library, museum, art gallery, archive service and aquarium in one building, which encourages working across the different disciplines. He says it is impressive that Bolton's collections contain the spinning mule worked on by Samuel Crompton – a machine that helped kick-start the Industrial Revolution. Other exhibits include machines manufactured by Dobson and Barlow, original technical drawings of steam engines from the Benjamin Hick Company as well as drawings and paintings by Thomas Moran of the American west. It is not often appreciated that two of the best landscape artists in American history – Thomas Cole and Thomas Moran – were both born in Bolton.

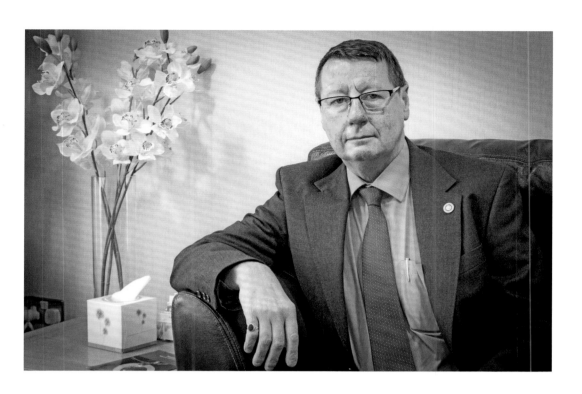
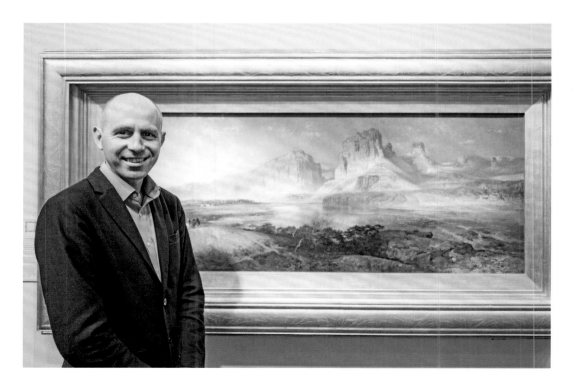

# FACES OF BOLTON

## MAURA JACKSON
### CHIEF EXECUTIVE OF THE BOLTON YOUNG PERSONS HOUSING SCHEME

*Maura set up the first Families Intervention Project in the country for Action for Children, established to help families who were at risk of homelessness because of antisocial behaviour. Her career subsequently took her to projects in Salford and Liverpool and then to Hammersmith, giving intensive support to women subject to domestic violence. In recent years she has returned to her roots in Bolton as the chief executive of the Bolton Young Persons Housing Scheme, which provides supported accommodation for young people who are homeless or at risk of becoming homeless. This was an interesting step given that she had spent some time in the organisation as a support worker more than fifteen years earlier. Tackling the many problems faced by young people can be challenging, but she clearly loves her job and the satisfaction it brings. However she still finds time for other activities, including being the chair of Endeavour, a local domestic violence charity.*

*She is proud to be living and working in Bolton, where people come together with a great sense of partnership. There is substantial voluntary activity devoted to supporting people, and the companies based in the town also give freely of their time and resources.*

## MICHELE PIDD
### SHOP SUPERVISOR FOR BOLTON HOSPICE

*Michele says she is a people person, having worked in a number of social places, including a nightclub. Currently she manages three shops in the Bolton area dedicated to raising funds for the hospice. She has lived in the town since 2004, having previously lived in Colne. When Michele and her husband sold their art framing shop in Bolton she decided she wanted to continue working and was particularly attracted to the hospice because of the valuable work they do. She identified with them because she had lost both her mother and sister to cancer. She volunteered for around eighteen months but eventually found a paid position with the charity, which has ten shops in total within the Bolton area. The shops, staffed by volunteers, generate a significant part of the income needed to support the hospice, although the charity's fundraising team are constantly active organising events throughout the year – a midnight walk, bake-a-thons, dance contests, sky diving etc.*

*She believes the two elements of town and country make Bolton what it is. Local people are lovely and very, very friendly and she particularly likes the local independent shops in centres such as Horwich.*

## MICHAEL TATMAN
### RETIRED SCHOOLTEACHER AND AMATEUR ACTOR

Michael is a man of many talents, from teaching classics, to acting and joinery. As a youngster Michael travelled the country with his parents, living in Harrogate, Surrey (where he witnessed the V2 bombing of London), and in Cornwall where he attended Bodmin Grammar School.

Michael delayed his further education to undertake the mandatory two-year National Service, later going to Cambridge University to study French and German. While at teacher training college a post was advertised for a classics teacher at Bolton School Boys' Division. He came for interview and was immediately struck by the friendliness of the people he met, which reminded of his early years in Harrogate. Within three years he was the Head of Classics and spent a fulfilling thirty-five years teaching.

To relax Michael turned his innumerable talents to acting, joining Bolton Little Theatre in 1969. As well as acting for over forty years, he has used his practical skills to build sets. Michael is still actively involved at the Little Theatre.

Probably Michael's greatest achievement has been establishing Bolton's talking newspaper. He recalls that in 1976 a man walked into Bolton Little Theatre looking for volunteers to help him start a scheme to provide local news on audio cassettes to people with visual impairments. Without hesitation Michael volunteered and for the last forty years he has played a major role in the continuing success of this community project.

## MUKESH SINGADIA
### AN EDUCATOR

*Mukesh has a passion for Bolton. Arriving from Kenya as a child in the late 1960s, he soon found that he enjoyed exploring the town and has fond memories of the Market Hall and the fountains on Victoria Square. The family quickly settled in Bolton, helped, Mukesh says, by his father's approach to life – taking a lead in the community and always putting others before himself. They were part of a close-knit community where people were proud of their families in their chosen new society.*

*Winston Morris was the inspirational mathematics teacher who encouraged Mukesh to achieve his academic potential, leading to a university place at Imperial College London. Mukesh was the first member of his community to attend university, which made his parents very proud. After graduation he decided to return to Bolton and contribute to the town by becoming a science teacher. In addition to his teaching role Mukesh has followed in his father's footsteps in acting as a translator and liaison between members of his community and local organisations and he also acted as a non-executive director of the local Health Authority.*

*Mukesh joined Sharples School in 1982 at a time when local textile and engineering industries were in decline, with difficult consequences for families and their children. He felt education was a very important ingredient in facing those problems and encouraged parents to become actively involved in their children's education. At the same time he was building up the science teaching at the school. In 1998 he became the first Deputy Head in Bolton from the Asian community and achieved a lifetime ambition when Sharples became a science specialist college.*

*Part of the science college's remit was to establish an astronomical observatory, and this was completed in the year before Mukesh retired from full-time teaching. The observatory is called the Singadia Observatory and was opened in October 2015. Paid for by local fundraising and grants, and with the support of the Bolton Astronomical Society as well as Rotary, the state-of-the-art facility is widely used by local schools.*

# FACES OF BOLTON

## MUSA PATEL
### POSTMASTER

'What a lovely gentleman.' 'How are you today Musa?' 'It's really lovely to have you back with us.' These were just some of the compliments I heard from customers at Harwood Post Office when I went to interview Musa Patel, the local postmaster.

Born in Northern Rhodesia in 1959, Musa came to Bolton when he was nine years old. His first school was Holy Trinity Catholic School, and he recalls attending the assembly and singing 'Onward Christian Soldiers.'

His first job was at Adam Greenhalgh Solicitors, and for ten years he undertook conveyancing, writing court briefs and general administrative work. However he always had a desire to own his own business, so in partnership with his father he set up 'Pandora Warehouse' on Deane Road. Although the business was successful, Musa's ambitions were not being fulfilled and so he decided to try working for the Post Office, his first job being in North Manchester. From there he came to Harwood, which he says was the 'Best thing that could have happened to me.'

Despite the trauma of having to deal with three robberies, two of which have been in Harwood, Musa says that the people of Harwood are so friendly and welcoming that he feels that they are like his extended family and can think of nowhere better to work.

## NIGEL BOOTH
### FIRE FIGHTER AND MOUNTAIN RESCUE SERVICE MEMBER

Nigel Booth is definitely a man of action. By the age of eighteen he was a competent scuba diver and sailor, and sailed with his friend from Holyhead to the Isle of Man, St Kilda and across the North Sea to Bergen. It was after this expedition that his mum said 'Its time you got a proper job and earned your keep.' So at the age of twenty-one Nigel joined the Greater Manchester Fire Service where he trained to be a firefighter. Nigel has worked throughout Greater Manchester, becoming a trainer before returning to Bolton North Moorland Fire Station.

This move enabled Nigel to fulfil another of his lifetime ambitions: to become a volunteer with the Bolton Mountain Rescue Service. So during his spare time he can be found working as part of a multi-disciplinary team helping to rescue people missing or injured on the moors above Bolton and throughout the North West. The work requires the mountain rescue service to work closely with the fire and air ambulance services, often in difficult and inaccessible places, dealing with moorland fires and, most sadly, recovering bodies.

Nigel explained that the most rewarding part of his career has been the opportunity to pass on his skills and experience to young people.

# FACES OF BOLTON

## NORA HOWCROFT
### THEATRE DIRECTOR AND CRITIC

When you first meet Nora you are immediately impressed with her enthusiasm for her lifelong love of the theatre and, in particular, amateur dramatics.

Nora has performed in numerous 'World Premiers', including Oliver at the Walmsley Operatic Society, the group being the first amateurs to perform this well-loved musical. This was followed by Nora and husband Donnie playing Mary and Pontius Pilate in Jesus Christ Superstar, followed by Jane in Calamity Jane with the Bradshaw Operatic Society, both again being firsts for amateur societies.

Nora had a desire to expand her repertoire by becoming a director and in the early 1980s her wish came true when she was invited to direct the well-known musical Hello Dolly with the guides and brownies of Harwood.

When Nora retired she and Donnie joined a local theatrical agency, which introduced them both to the world of modelling and advertising and this led to the occasional television appearance. Probably her most notable performance was as a jury member in the infamous trial of Coronation Street's Deidre Barlow.

Another highlight for Nora and Donnie was the invitation to attend a garden party at Buckingham Palace in 2010 at which Prince Michael of Kent was present.

## OLWEN BAKER
### LOCAL PREACHER

If you are a Methodist and live and worship in Bolton then Olwen Baker will be a familiar face to you, because she has been a local preacher for over sixty years and is still actively preaching in churches in Bolton.

Olwen's other great love is music. She learnt to play the piano at a young age and progressed through the exams to eventually become an Associate of the London School of Music (ACLM). As well as the piano she also plays the organ, and one day, when time permits, she says she would love to learn to play jazz.

After leaving college, Olwen worked at Bradshaw Gass and Hope for thirty-seven years, before making a career change and taking up a new challenge working as a development officer for the Methodist Housing Association, where she project managed numerous schemes to provide affordable homes in the North West. Currently she is the chair of the board of the Adactus Housing Association.

Aside from her work, preaching and music, Olwen loves to paint, mainly in oils, and has her work on display in her home. Her style could be described as 'with a flourish' — not unlike Olwen herself.

## NORMA RUTHERFORD
### EVENTS OFFICER, BOLTON COUNCIL

*What have Hollywood's 'Sly' Stallone, television hit* Shameless *and our own Bolton Santa got in common? Why it's Norma Rutherford who, in her capacity as the council's Principal Events Officer, brings all this together.*

*Keeping Bolton's profile bubbling is a key spin-off from the various hats she wears, liaising with film-makers, Bake Off stars, organising the Christmas Lights Switch On and the hugely successful, award-winning Food and Drink Festival, now attracting over a quarter of a million visitors!*

*Sylvester Stallone (Warburton's advert) and Santa have trod the imposing Town Hall steps along with many other Bolton celebrities and film and television actors.*

*Norma's other successes have included leading the town's Millennium Celebrations, Bolton's 750th Charter Anniversary event and the BBC One Big Sunday, which saw 100,000 people flock to Moss Bank Park for a free concert hosted by Bolton's own Sara Cox; not to forget the hugely successful Commonwealth Praise event in 2002 and the Olympic Torch Relay celebrations in 2012.*

*Norma's wealth of experience means she is able to bring everything together with a professional expertise that brings film, television and event producers back to Bolton. It's a huge remit, demanding careful attention to detail and often the skill of a professional diplomat, but one which she loves.*

# FACES OF BOLTON

## PAUL SEDGWICK
### TOWN PLANNER

Paul has lived in Bolton for forty years, so can certainly consider himself a local. After leaving school he took a job in Buckinghamshire County Council's town planning office – at a princely salary of £425 per annum. After several other job moves he was offered a position with Bolton in 1976, where he had a significant role in shaping the plans for Greater Manchester as well as helping improve Bolton's river valleys, which had been despoiled by industry. By this time Paul was appearing at public inquiries and found the experience interesting and rewarding. Given his success there, it is not surprising that he was offered a job with a consultancy to focus on that kind of activity. Then in 1998 he launched his own consultancy based in Bolton – Sedgwick Associates – and had considerable success acting for clients large and small, particularly in the field of housing. As a planner of fifty-two years' standing, Paul believes he is one of the most experienced in the business. Outside work Paul and his wife Brenda have become involved in long-distance running again. He feels very attached to Bolton, pointing in particular to the way the river valleys bring countryside into the town.

## PHIL RIDING
### CHARTERED ACCOUNTANT

Phil has 'a strong affection and deep-seated link with Bolton'. His family owned Boydell's, the former independent toyshop in Oxford Street, Bolton. He could have settled in Bermuda but chose to remain in Bolton because of its combination of mature professional services, excellent sporting opportunities and great location. He says Bolton is a lively place with its own unique identity. Phil has been president of the Bolton Society of Chartered Accountants and he points out that Bolton has a greater number and quality of professional services than many of the Lancashire towns north of Manchester. He has been an enthusiastic player of team and racquet sports over the years and is a firm believer not only of playing his part in the team, but also helping to organise things. He has coached at the Ladybridge football club, and runs the junior section at the Bolton Golf Club. Phil has been quick to volunteer for other activities and has served on the Scout Council for Bolton School and been involved with the Old Boltonians for twenty-five years, acting as treasurer. He was also a founder member of his Rotary Club, where he has taken on the presidential role.

# FACES OF BOLTON

## RICHARD OLDFIELD
### KITCHEN AND BATHROOM FITTER

*Born in Bolton, Richard nevertheless lived in Canada for a couple of years before returning to Bolton as a young child. Although he didn't hit the academic heights at school, he does feel that he had developed as a person wishing to help others. Following school Richard gained a wide experience of the building trade, which eventually led him to begin working on his own account. Another spell in Canada followed, but when this didn't satisfy his needs, Richard returned to Bolton and decided to join the Army hoping to become a qualified physical instructor. But the qualification never came since, instead, he was required by the Queen's Lancashire Regiment to serve in Serbia, Sierra Leone and Northern Ireland. On leaving the Army, Richard soon took up garage conversions. Business declined as the depression hit, but as people turned to refurbishing their houses rather than moving home, Richard decided to move into the design, supply and installation of bathrooms and kitchens. He has made a sure success of this for the last decade. Richard rates Bolton – 'It's not all Coronation Street.' He particularly likes the stories associated with its important industrial history and the pride people have in their town.*

## RON EADIE
### MASTER BAKER (RETIRED)

*Ron Eadie, better known to his friends as 'Mr Kipling', has spent most of his life in the bakery business. After losing an eye in a stone fight with his mates in his home town of Buckhaven, Fife, Ron was told that he was probably 'unemployable'. However an interest in cooking resulted in him applying to the local catering college, where he obtained the Scottish National Diploma in baking – and he never looked back.*

*After numerous jobs that broadened his experience, Ron got a job with the Rank Hovis McDougal organisation as a product development baker. This led him to work on the development of a range of products, including the famous Mr Kipling Cherry Bakewell Tart.*

*A further career move brought Ron to Bolton as a bakery technologist for Warburton's, where he advised on the development of a range of recipes. His skills in solving problems resulted in him advising several local bakeries on product improvement.*

*Ron retired in 2007 but still continues to bake and has worked part-time for the local Meals on Wheels service and at the former Egerton House Hotel. He is a freemason, a keen member of Bolton Lions and the Rotary Club of Bolton Daybreak and works tirelessly to raise money for local charities.*

# SAEED ATCHA
## YOUTH ACTIVIST

*From the age of fifteen Saeed has developed a strong involvement in media, especially magazine publication. This was triggered by articles that appeared in the press criticising young people after the riots of 2011. Saeed decided to act directly to produce an antidote by editing his own magazine – Xplode. Despite still being at school, he pitched the idea of a magazine created by and for young people to O2. They loved the idea, funded it, and supplied a mentor. Subsequently O2 also set up an arm of their organisation to focus on young people. By 2013 the decision was made to set the magazine up as a registered charity, and readership has rocketed to the point where 5,000 printed copies are produced. Today Saeed is the chair and chief executive of the charity. All those involved, including Saeed, are volunteers. The articles in the magazine are commissioned in a professional manner with progress reports and deadlines to give the young authors realistic experience in the field of journalism. Saeed is very proud that the organisation recently received the Queen's Award for Voluntary Service. This subsequently led to him being involved with the national Step up to Serve initiative, aiming to double the level of participation by young people to help others.*

*In addition to the magazine, Saeed has also worked as a broadcaster on Tower FM and more recently presents an evening show across twelve radio stations, broadcasting from Stoke on Trent. After graduation from his public relations and marketing degree at Manchester, Saeed aims to set up a PR Agency as a consultancy for the charity sector that is affordable and does all the basic things. Meanwhile he is planning to expand Xplode, initially across the Greater Manchester area.*

*Although his work frequently takes him to London, he is always glad to be returning to Bolton since, as Saeed says, Bolton is such a great town – once voted the friendliest town in the United Kingdom. It is very diverse and has its own identity.*

# FACES OF BOLTON

## SAM WORRALL
### DANCE TEACHER

Sam has danced since the age of eight, training at the Rhodes Dance School in Aspull. However, when that school closed, she needed an alternative. Although Sam had been working at the Wigan Reporter since she left school, she harboured a desire for a career in dancing. The Sandham Dance Studio in Farnworth saw Sam's potential and she became their first full-time employee. Being qualified with the International Dance Teachers' Association means that she can teach both children and adults — something she does with consummate skill, tact and patience. She also coaches people for their dance exams, where the school has a good success rate. Teaching involves working unsocial hours, and Sam has had great support from within her family to allow her to maintain her role. Sunday evening social dances and themed dance weekends add to the regular weekday arrangements, which often see her return home around 11 p.m. Sam finds her work very rewarding, dealing with people who have, after all, come along to enjoy themselves. Many lifelong friendships are made at the dance school and partnerships are also forged there. Dancing is very therapeutic — and as she says, 'dancing is good for exercise and the brain'.

## SARAH JANE PATE
### TEAROOM OWNER

Although Sarah had spent some time in an office at the Hospital Saturday Fund, she decided she would much prefer the atmosphere and the variety of people she met in a coffee shop and was easily persuaded to join her sister in her café in Horwich. Following that she worked in the sandwich room at Greenhalgh's bakery and subsequently worked for the Range, where she ensured their new in-store coffee shops were ready to open in Southport and Blackburn. However, during a break from work, Sarah decided to try her hand at baking and found herself supplying cakes to a local restaurant. As a consequence, and with the support of her husband, Sarah took the bold step to set up a tearoom in Horwich, which required the complete refurbishment and reorganisation of the premises. Three years later she has an attractive business with happy customers consuming cakes, all produced on the premises.

Sarah really likes the Horwich area and takes a walk each morning before opening the tearoom to look over the town and appreciate the stunning views and the wildlife. Seeing wild deer on her walks is not at all unusual.

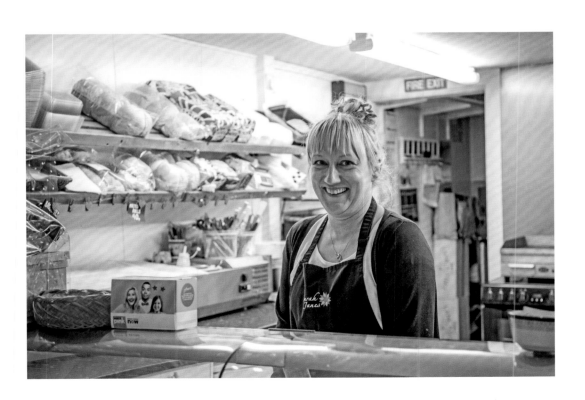

# FACES OF BOLTON

## SHAHEEN SAMEJA
### PUBLIC SERVANT

*Shaheen trained as a baker on leaving school – her father felt such a vocation would be useful wherever life took her. Nevertheless Shaheen had her own ideas and soon took a job supporting home workers who are often isolated and can be unsure of their rights. The expertise she developed took her to international conferences and stimulated her desire for further education, which she followed very successfully at Lancaster and later Durham universities. Shaheen has always felt the urge to serve the public and has achieved this in such diverse ways as being a policy officer for the local authorities of Greater Manchester, working for charitable bodies, and even consulting the public on the location of mobile phone masts. Nowadays Shaheen is the area manager of the Halliwell and Crompton wards of Bolton, acting as a catalyst to bring organisations together to improve public services and address problems of deprivation. She also looks after the Halliwell UCAN local drop-in centre, which keeps her in touch with local people and their issues. Shaheen is very optimistic about the diverse communities who have come to live in Bolton and believes they have a lot to offer, coming together for mutual benefit.*

## STEPH SHIPLEY
### ARTIST

*Steph Shipley is an extraordinarily talented local artist. After obtaining a degree in French, she worked in IT for several years, but when she was made redundant in 2009 she decided to pursue a childhood ambition – that of becoming an artist. She enrolled on an art and design course at Bolton University and, for her, it was life changing; an opportunity to explore and experiment, and to learn new techniques in a variety of mediums.*

*Steph's first project was to create two memory boxes. When both her mum and dad had died, she found grieving very difficult. Creating the boxes, which include many mementoes, has helped her to grieve and she says the boxes are very precious to her.*

*A Fine Arts degree, again at Bolton University, was to follow. She took a part-time job at a local nursery, which allowed her to devote more time to her art and in 2015 she graduated, winning the Vice Chancellor's prize for outstanding work. This was followed by an award from the National Association of Decorative and Fine Arts.*

*Currently Steph is experimenting with a range of techniques including solar-plate etching and intaglio printmaking. Steph's work can be found in local art galleries and exhibitions.*

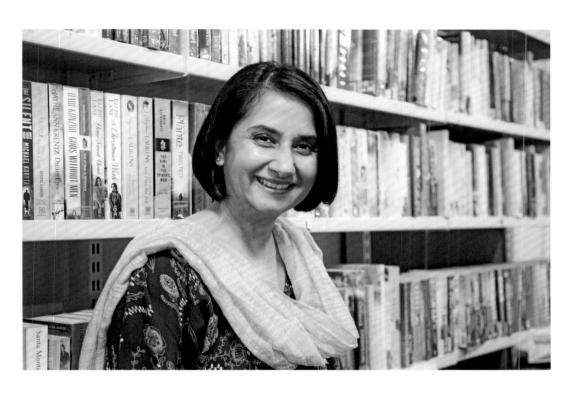

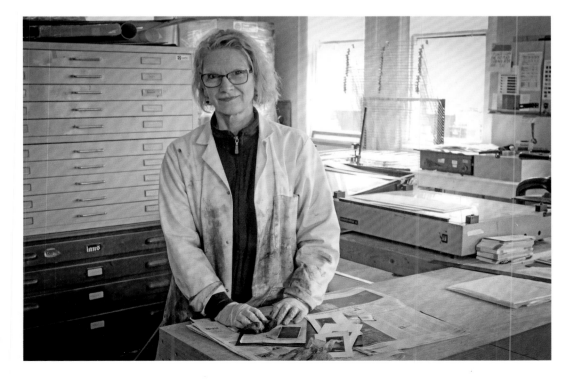

# FACES OF BOLTON

## SUSAN WADDINGTON
### PERSONAL ASSISTANT TO A HEAD TEACHER

*Susan's father was a coal miner and she spent her early years in Oldham, although her family soon moved back to the Farnworth/Kearsley area. She is proud to be a Boltonian. Susan's husband was a firefighter. They were married on 14 November 1981 and held their reception at the Beehive in Lostock. Unfortunately that was the night of the major fire at Bolton town hall, which resulted in a shortage of guests, many of whom were needed to tackle the blaze – but luckily not the groom. Subsequently Susan worked for nearly thirty years at the Bolton Institute of Technology (now University), latterly supporting major expansion works, including the refurbishment of Eagle Mill. When she left that job Susan thought she would enjoy an easier life, but boredom soon set in, and she is very pleased that she now works as part of the team in the Bishop Bridgeman Primary School. Being around children is always a delight and she enjoys the challenge of helping organise a conference at the school for children each year, drawn from around thirty schools. Asked about Bolton, she says it not only has a very interesting history but also has the finest water in the country.*

## TONY ASPINALL
### PROPRIETOR, BOOTH'S MUSIC SHOP

*Tony claims that Booth's Music shop is probably the oldest family music shop in the world and if anyone knows better then please let him know.*

*Opened in 1832 by James Booth, the business has been in Churchgate for nearly two hundred years, although originally it was a few doors closer to Deansgate. Tony, who has worked in the business for forty years, is the great great great grandson of the founder. His mum, Freda, who is eighty-seven, stills plays an active role in the business, as does his wife, Jean, and their son, James.*

*Tony recalls that in his early days the business was all about selling sheet music. Now everyone downloads their music from the internet. So, to survive, Tony has diversified into the music tuition business. The basement and upper rooms have been converted into soundproof booths, which local music teachers hire to give lessons. There is even a recording studio for budding stars to record their music and songs.*

*Tony is a musician in his own right, being a bass guitarist who has played with Status Quo as well as internationally. Nowadays he spends three to four afternoons a week in his workshop repairing instruments of all kinds – from violins to saxophones.*

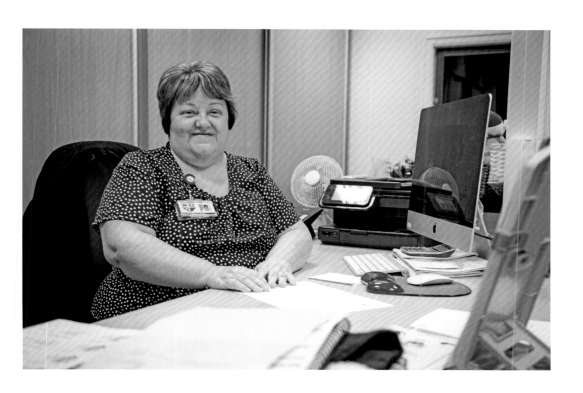

# TASOS
## RESTAURATEUR

*The right ambience, excellent service and good food are the ingredients for a successful restaurant according to Tasos Pattichis. And he should know, having run a very successful fish and chip restaurant in Bolton for over twenty-five years. Although Tasos was born in Cyprus, his family have been based in Britain since the 1950s, running a number of restaurants in the North West of England before settling at the former Olympus Grill in Churchgate. He says his parents have a strong work ethic, which he has inherited. Having been brought up in catering, it is not surprising that Tasos has continued in the family tradition, although that wasn't always the idea. In his mid-twenties the family acquired a shop in Great Moor Street and Tasos's intention was to renovate it, open it as a fish and chip shop, sell the business and then move on to another project. However, this required him to become a competent fish fryer. To achieve this he offered his services for free to friends and relations who were in the business and, by this means, became a successful fryer. However, the shop was only just viable as a take-away establishment and Tasos was drawn in and wanted more. Opening a restaurant became his clear ambition. Acquisition of adjoining premises followed and the Olympus Fish and Chip Restaurant was born.*

*Tasos has never been a person to rest on his achievements however, and has always been ambitious to do more. This culminated in a major expansion into their current corner site in the 1990s. Today he has an obvious success on his hands, but, as always, is seeking ways to innovate. As well as introducing live music he is now promoting coach tours to resorts and towns. The restaurant has been used for live theatre in conjunction with the Octagon and, following a competition, he has also considered the introduction of dancing to the restaurant on a regular basis. Tasos feels that Bolton people have been like an extended family, helping him to develop his business.*

# FACES OF BOLTON

## FATHER TONY DAVIES
### ANGLICAN PRIEST

*Fr Tony started work in a chartered surveyor's office and worked for over five years with Alexander Reece Thomson in London. During this time he had notions to serve in the church, which led him to attend the theological college in Mirfield, Yorkshire. Positions in Stalybridge and Swinton followed, but in 2002 Fr Tony took up his post at St Augustine's, Tonge Moor. The church has a particular relationship with Our Lady of Walsingham whose shrine in Norfolk has been visited from Bolton for over sixty years. Fr Tony believes the church is a great resource for the community, supported by a well-equipped meeting hall in the undercroft (commonly referred to as the 'Crypt' after a former youth club several decades back). In spite of being busy with parish affairs, Fr Tony has found time to develop an interest in scuba diving and joined Bolton Area Divers as a dive master, able to assist in teaching diving skills. He believes local people are proud of their town and that the diversity of the population has been and can continue to be very positive provided we rise to the challenge of the pace of change experienced in recent years.*

## TRACEY GARDE
### FUNDRAISER

*Tracey Garde has worked at Bolton Royal Infirmary for close on thirty-five years. She is currently Matron for Cardiology, Diabetes and Dermatology. Tracey finds her work stimulating and satisfying. However, having seen the after-effects that a heart attack can have upon patients and their families, she set her mind to finding ways to help them deal better with this trauma. So in 2006, with help from a consultant colleague, she formed a support group for patients that had been fitted with implantable cardiac defibrillators, the aim being to bring together patients and family carers so that they could share experiences and give mutual support to one another. Tracey explained that cardiac arrests can affect people of all ages; indeed, each year in the U.K. between twelve and fifteen young people under the age of thirty-five suffer cardiac arrests and for those that survive, having an implantable cardiac defibrillator is literally a lifesaver.*

*In 2012, Tracey decided that lives could be saved if there was better access to defibrillators, and so she formed a fundraising group with the aim of providing defibrillators to every school and public building in the Bolton area. Five years on Tracey is proud to say that over 120 defibrillators have been installed.*

# THE AUTHORS

*Both Ray (left) and Jeff (right) have been keen photographers for more years than they wish to remember. Friends for more than twenty-five years, they are both members of the Bolton Camera Club and Bolton Documentary Photography, a community voluntary organisation dedicated to recording aspects of everyday life in Bolton, following in the footsteps of Stephen Spender, the photographer who helped document 'Worktown' (Bolton) in the 1930s. Jeff and Ray are both active in Rotary and the Arts Society and individually help out in other local organisations. Although they are 'off-comers', they nevertheless feel a strong attraction to the town they have chosen to be their home and where they have lived for more than a generation. Now retired from demanding jobs, they try to find time to put something back into the community by volunteering and supporting local societies, while enjoying the advantages of living in a friendly and attractive part of the country.*

*Photo: David Hawkins.*